IMAGES
of America

GLEN ROSE

TEXAS

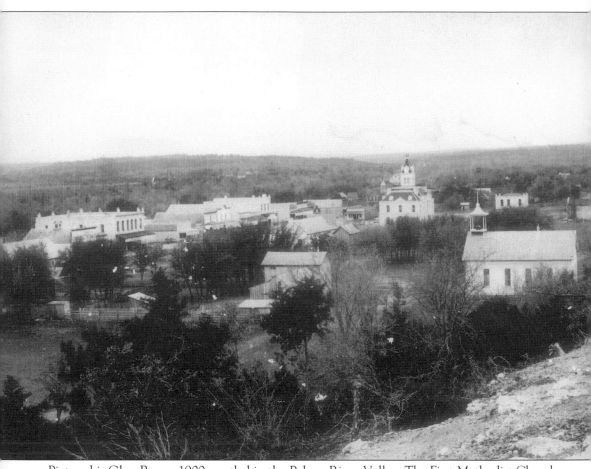

Pictured is Glen Rose c.1900, nestled in the Paluxy River Valley. The First Methodist Church is in the foreground. (Courtesy of Troy Burns; Linda Drake Photography)

IMAGES
of America

GLEN ROSE

TEXAS

Gene Fowler and the
Somervell County Historical Commission

ARCADIA

Published by Arcadia Publishing,
an imprint of Tempus Publishing, Inc.
3047 N. Lincoln Ave., Suite 410
Chicago, IL 60657

Printed in Great Britain.

Library of Congress Catalog Card Number: 2001095423

For all general information contact Arcadia Publishing at: Applied for.
Telephone 843-853-2070
Fax 843-853-0044
E-Mail sales@arcadiapublishing.com

For customer service and orders:
Toll-Free 1-888-313-2665

Visit us on the internet at http://www.arcadiapublishing.com

CONTENTS

ACKNOWLEDGEMENTS

This book would not have been possible without the help, cooperation, and photographs given by many people. Some are listed here but constraints of space keep us from listing all who have contributed. Rest assured that your efforts are appreciated.

Dorothy Jo Osborn—For her patience and willingness to see this book's publication.

Ruth F. Parker (in memoriam)—without whose mentoring and inspiration this could not have been attempted for preservation of our heritage. She saw the importance of preservation in the days when the town and county were too poor to afford housing for the documentation. To her, published books were the best form of dissemination of our history to the public.

Commissioners' Court—Judge Walter Maynard; Commissioners Helen Kerwin, Lloyd Wirt, Zach Cummings, and Foy Edwards; County Attorney Ron Hankins; County Auditor Darrell Morrison; for their approval and assistance.

Dan McCarty
Cil Holloway—for her support, computer experience, and calm judgement.
Ken Thrasher
Maxie Parker Leach
Jeanne Mack
Nancy Willis
Bonnah Boyd
Somervell County Historical Commission membership

Special thanks go to Dorothy Leach who conceived, nurtured, and persevered during the long work-in-progress process to bring this book to completion. To Terry Covey who gave of his valuable knowledge about Glen Rose and his time and support. To Ken Fry, Chairman, who saw the importance of preserving this era in our history and supported every effort to bring it to realization.

Somervell County Historical Commission

INTRODUCTION

Long before Dr. E.B. Earp coined the slogan, "Glen Rose for Health and Pleasure" in 1929, Native Americans had been visiting the idyllic site for generations. Tonkawas and Caddoan bands camped at riparian springs of healing waters. They swam in the flowing Paluxy River and hunted in the limestone hills. Their legends still haunt the rocky bluffs that soar above the meandering river.

Settlement of the valley began about 1860 when Charles and Juana Cavasos Barnard built a grist mill on the banks of the Paluxy. The community that sprang up became known as Barnard's Mill. After Barnard sold the mill to T.C. Jordan of Dallas for $65,000 (paid in $20 gold pieces), Mrs. Jordan renamed the verdant oasis Rose Glen for its tangles of vines and wild roses. A community vote reversed the name to the equally poetic Glen Rose.

In 1875, the village became the seat of Somervell County, and Jordan donated land for a courthouse square. He added a cotton gin to the mill, and for a time, the snowy white fiber became the mainstay of Glen Rose's economy, as it did in many a small Texas town.

Glen Rose, however, was no run-of-the-mill burg. As early as the 1870s, the population of about 350 grew in the summer. Campers in covered wagons flocked to the valley to drink the bracing spring waters laced with healthy doses of sulphur and other minerals. The first of Glen Rose's famous flowing wells was drilled in the 1880s.

In time, hundreds of the artesian fountains gurgled and spurted from the Somervell County soil. Magnetic healers, chiropractors, and massage therapists established sanitariums, and parks dotted the winding Paluxy where folks could stay in cabins and relax under massive oaks, elms, and pecans. Visiting Glen Rose for "health and pleasure" indeed became a substantial part of the local economy.

In the 1920s and '30s, one pleasurable pastime, guzzling the bootleg firewater cooked in the hills, crowned Somervell County as the "Moonshine Capital of Texas."

Guests in the "dimple in the cheek of Texas" also came to "Dinosaur Valley" and the "Petrified City" to admire the area's abundance of prehistoric dinosaur tracks, as well as the many homes and other buildings constructed with petrified wood. Some came seeking the fabled haunts of the mysterious John St. Helen, a Glen Rose pioneer later rumored to have been John Wilkes Booth, assassin of President Lincoln.

Today, folks still come to splash in the Paluxy. They come for bluegrass festivals, religious pageants, wildlife tours, and just to chase away the big-city blues, but it's important—it's a necessity of life - to remember days gone by, places and people come and gone.

In that spirit, the Somervell County Historical Commission dedicates Glen Rose for Health and Pleasure to Don and Vivian Hill and to Dr. E.B. Earp's daughter, Dorothy Jo Osborn, for preserving many of the images in this book.

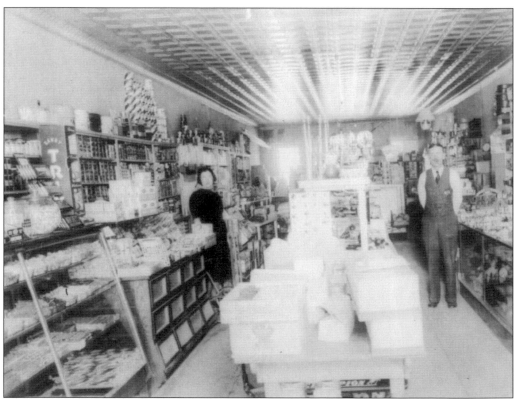

Don and Vivian Hill stand ready to assist customers in their store on the square. "Hill's store, with its candy and toys, was the most fun place to go as a kid with a nickel," says Dorothy Leach. "I'm sure many a child went there to play with the toys, not being able to afford to buy anything. But the Hills were always tolerant and patient." (Courtesy of Johnny and Marvilene Martin)

One
PIONEER DAYS

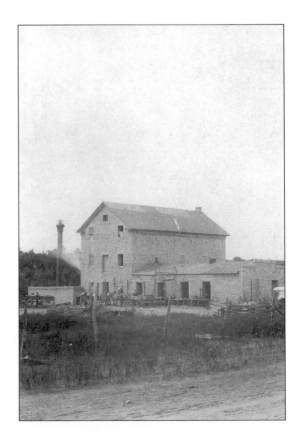

This is a cabinet photo of the
Barnard/Price mill and gin. Built in 1860
on the limestone bed that cradles the
Paluxy, the stone mill has endured.
(Somervell County Museum)

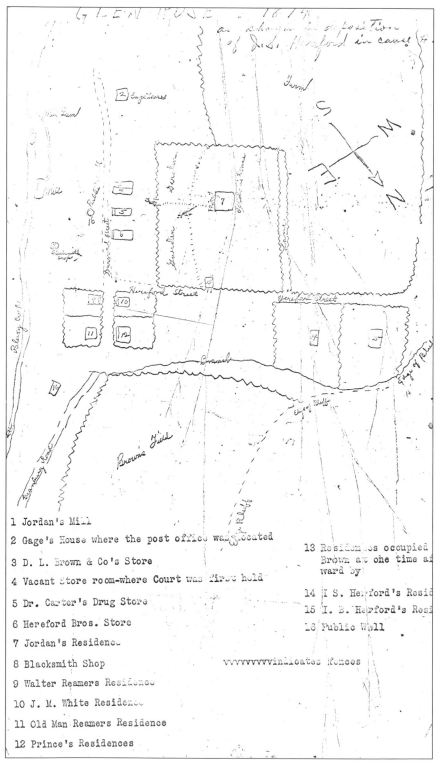

1 Jordan's Mill

2 Gage's House where the post office was located

3 D. L. Brown & Co's Store

4 Vacant Store room-where Court was first held

5 Dr. Carter's Drug Store

6 Hereford Bros. Store

7 Jordan's Residence

8 Blacksmith Shop

9 Walter Reamers Residence

10 J. M. White Residence

11 Old Man Reamers Residence

12 Prince's Residences

13 Residences occupied Brown at one time afward by

14 I S. Hereford's Resid

15 I. B. Hereford's Resi

16 Public Well

vvvvvvvvvvindicates Fences

Pictured is a map of Glen Rose in 1874. The first two streets were Barnard and Hereford. Charles Barnard dug the public well (#16) near his mill, and provided free water to early settlers. The well was still there in 2001. Brown's Field at the bottom of the map is the present-day courthouse square. (Somervell County Records)

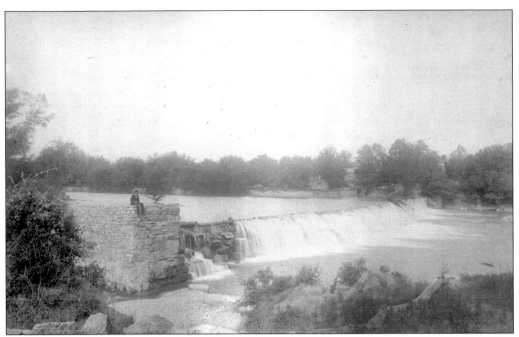

Charles Barnard built a dam on the Paluxy for T.C. Jordan after Jordan bought the mill. The dam held up more than 40 years, and is seen here in the 1880s. (Courtesy Ruby Gresham Leach Collection)

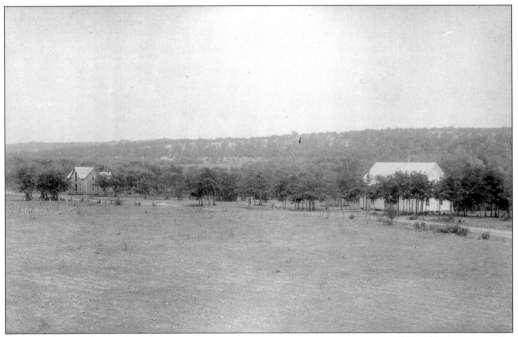

This is a view from the Presbyterian College building looking southward in the 1880s. The white building is the first Baptist Church in Glen Rose, built in about 1885, sitting on present College Street. The dwelling sat on the Martin property that is now Oakdale Park. (Courtesy Ruby Gresham Leach Collection)

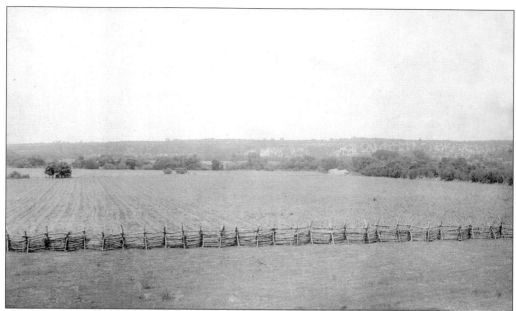

Shown is a view from Presbyterian College building looking northward in the 1880s. The rail fence is approximately where Holden Street is now, behind the old school campus. The road to the Texas Amphitheatre presently runs along the ridge on the horizon. The right hand edge of the field is now Gaither Street; the cabin in the trees sat beside one of the roads coming into Glen Rose. The field now contains Highway 67, the Church of Christ, Chachi's, car washes, homes, and a school athletic field. (Courtesy Ruby Gresham Leach Collection)

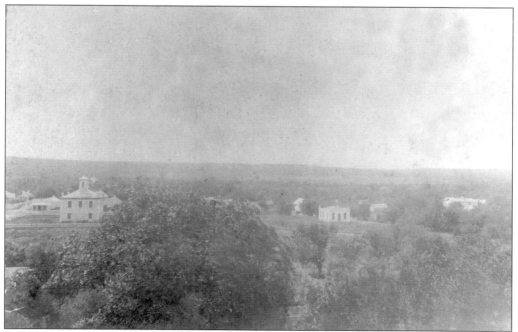

This is downtown Glen Rose, 1880s. Pictured is the first courthouse in the present location, the jail, the still-standing Willingham home on Grace Street, and the mill. (Courtesy Ruby Gresham Leach Collection)

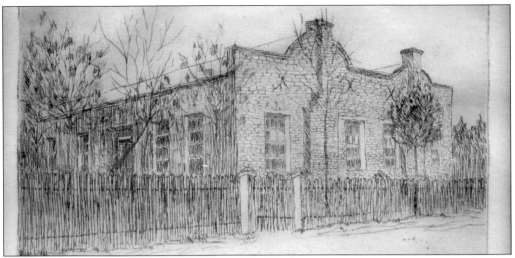

In the 1860s and '70s, Indian raids were a constant danger. Few grasped that fact better than founder Charles Barnard's wife, Juana Cavasos Barnard. As a girl, the Matamoros native of Spanish-Italian heritage was kidnapped by Comanches. Years later, Charles' brother George "ransomed" Juana from Indians at the Tehuacana Creek Trading House south of Waco, which the Barnard brothers operated (later, the brothers ran another trading post near present Glen Rose). When Charles laid eyes on the dark-haired beauty, it was love at first sight. In the 1860s the Barnard home across the road from the mill, shown here in an etching by Lena Glenn Spears, granddaughter of A. J. Price, was the scene of dances, church meetings, court sessions, etc. (The mill also served some of these functions.) After a storm cracked one of the walls in the 1910s, the home was torn down and rebuilt on the site with the same materials. (Sketch courtesy of Somervell County Museum)

One pioneer arrival seemed out of place to many Glen Rose folks. John St. Helen lived in a cabin near the mill. An old-timer recalled that the cabin doubled as a store with "a barrel of whiskey, a poke of green coffee, some tobacco, and supplies." But St. Helen was given to reciting passages from long-dead dramatists and other odd flourishes. When word went round that a lawman was coming to marry a local girl, St. Helen disappeared. Years later, on his deathbed, he confessed to being the assassin of Lincoln, John Wilkes Booth. The strange man returned to Glen Rose in an even stranger condition in the 1920s, as a mummy touring the carnival circuit. Peering at the lifeless form, old-timers confirmed it was St. Helen. He is seen here in the 1907 book, *Escape and Suicide of John Wilkes Booth*, by Granbury lawyer Finis Bates, to whom St. Helen once confessed. Bates was probably a good lawyer, but he tended to mix up his rivers. (Glen Rose is on the Paluxy not the Bosque.) (Courtesy of Gene Fowler.)

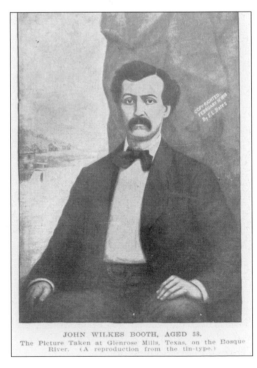

JOHN WILKES BOOTH, AGED 38.
The Picture Taken at Glenrose Mills, Texas, on the Bosque River. (A reproduction from the tin-type.)

13

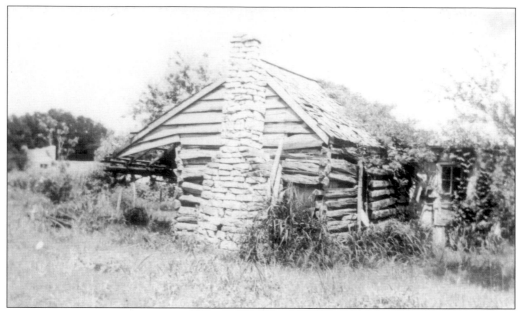

According to local tradition, St. Helen may have sold hooch out of this cabin. which stood near the mill. It was later moved to the courthouse square and no longer stands. (Courtesy Somervell County Historical Commission)

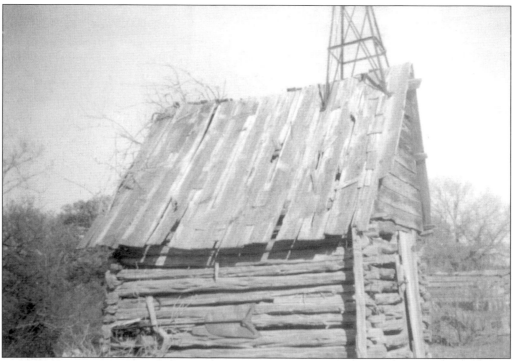

St. Helen kept corn for his customer's horses in this corn crib, which still stands in Glen Rose. (Ruth F. Parker Collection; Booker Family photo.)

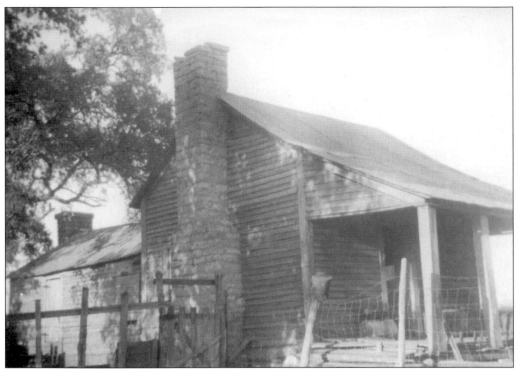

This is another cabin, its logs covered with siding, alleged to have been St. Helen's. It still stands on Wheeler Branch in 2001. (Courtesy Ruth F. Parker Collection)

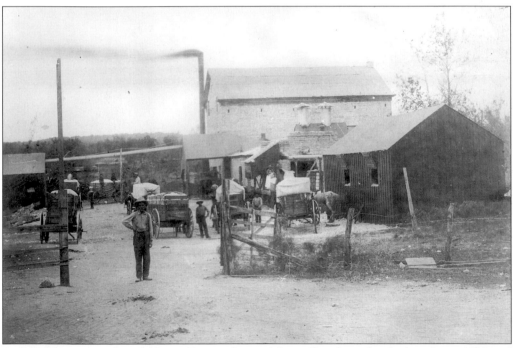

A. J. Price is pictured c. 1918, standing in front of the mill and gin that he bought in 1890 and operated for 50 years. (Somervell County Museum)

The George L. Booker family stands in front of their home, one of the earliest known dwellings in Glen Rose. A. J. McCamant built and lived in it; afterwards the Bookers lived in it for nearly 100 years. The Booker family served their community as surveyors, teachers, church leaders, and keepers of Glen Rose history. George Booker served the Confederacy at Appomattox with General Lee. Pictured from left to right are (front row) John Olen, Lorena, Josephine, Marvin, Karl, and George Jr.; (back row) Nell, Moody, Nannie, and George L. Booker. Elizabeth and Sam are not present. (Booker Family photo)

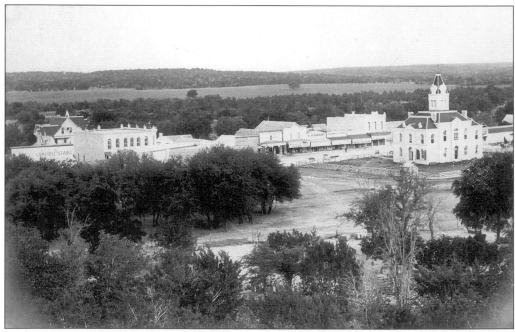

This is a view of downtown, pre-1902. (Don and Vivian Hill Collection)

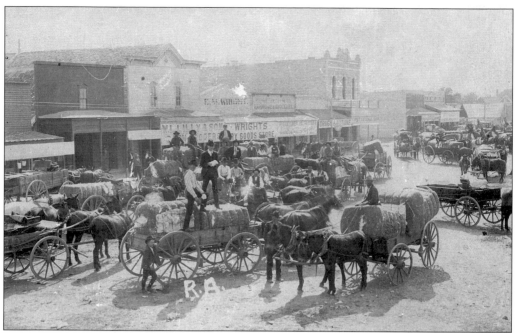

Here is an image of bringing cotton to town, 1907. Before World War I, cotton was an important part of Glen Rose's economy. (Don and Vivian Hill Collection)

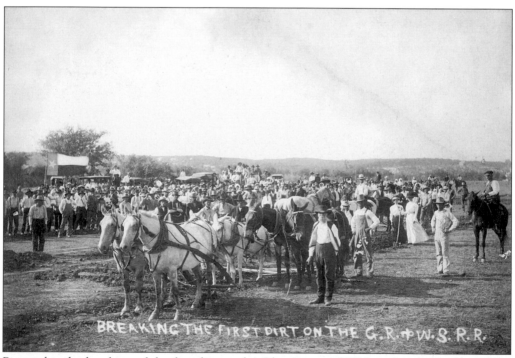

Pictured is the breaking of the first dirt on the Glen Rose and Walnut Springs Railroad. The "second dirt" remained unbroken, and Glen Rose never had rail service. That may have hampered its growth, but it also helped preserve the village's mystique as a "hidden" pocket of paradise. (Somervell County Museum)

Goin' to town. (Somervell County Museum)

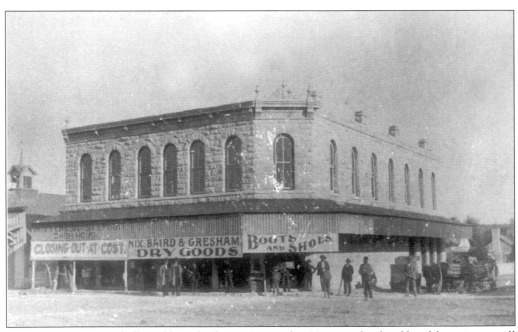

The two-story Campbell Building, built in 1894 with 420 wagonloads of local limestone, still stands on the square at Walnut and Barnard. (Somervell County Historical Society)

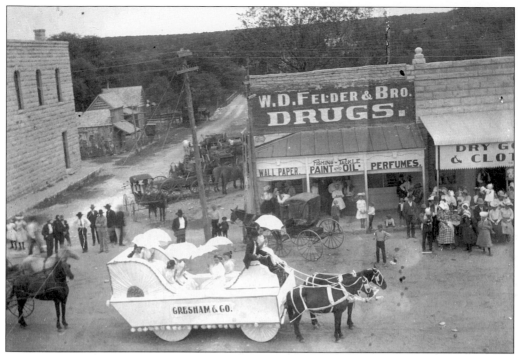

Here is Gresham's float in the Trades Day Parade, 1906. Pictured are driver Lewis Gresham with Ruby Gresham (Leach) beside him, Angie Price (Thomas), Lela Gresham (Edmiston), and Lela Herring (Carter). (Somervell County Museum)

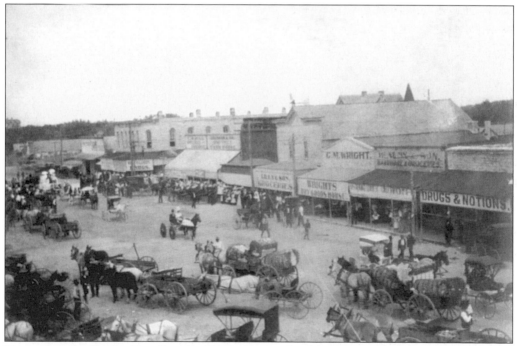

Pictured is the Trades Day Parade, 1906. An April celebration marked the opening of the spring trading season. (Somervell County Museum)

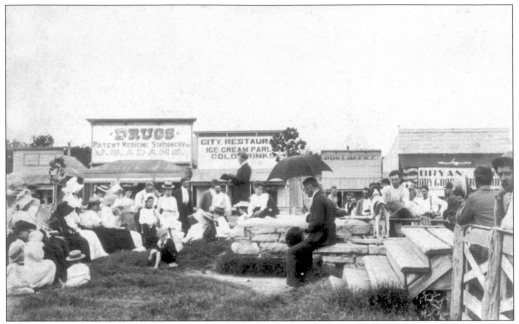

Fire and brimstone preaching on the square. Most of the buildings in the background burned in about 1905. (Somervell County Historical Society)

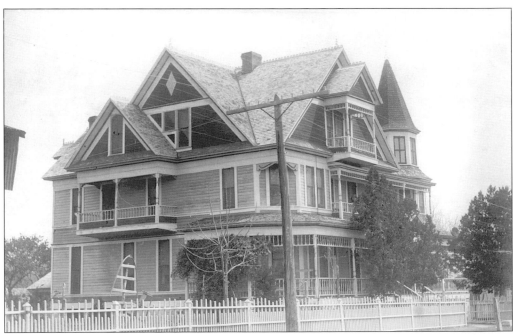

The Campbell Hotel, operated by Dr. T. B. Campbell, was "First Class in Every Respect." Located on the corner of Grace and Walnut, it was torn down around 1926. (Don and Vivian Hill Collection)

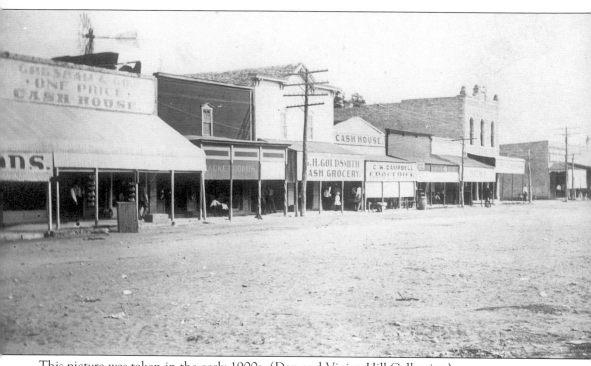

This picture was taken in the early 1900s. (Don and Vivian Hill Collection)

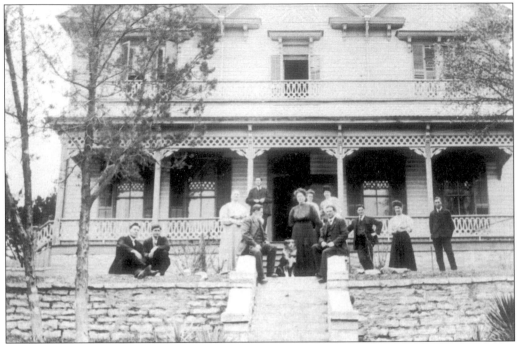

The Lilly House on Barnard Street still stands in 2001 as the Lilly House Bed and Breakfast, one of many in Glen Rose. The William L. and Sarah Lilly family, standing in front of the house, includes Lora, Walter "Dutch," E.L. "Pete," W.W. "Buck," James L. "Jim," Elmer George, Cora, and Dora. (Somervell County Historical Society)

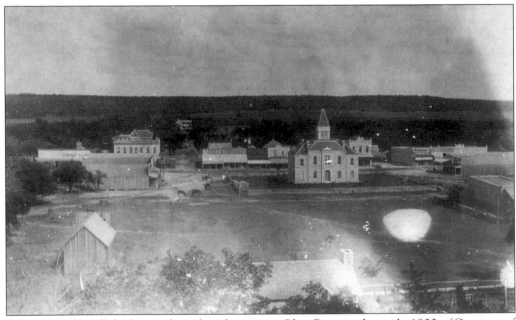

A horse could still find a good meal in downtown Glen Rose in the early 1900s. (Courtesy of Lila Carter from T. J. Price Collection)

Two

DINOSAURS— PRE-HISTORY

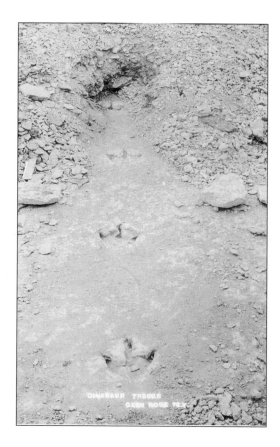

Glen Rose youngster George Adams was splashing across Wheeler Branch in 1908 when he noticed some animal footprints. BIG footprints. His teacher, Robert E. McDonald, identified the critter as a dinosaur. Years later, another local fellow, Charlie Moss, discovered even larger tracks in the Paluxy River, made by the plant-munching *Pleurocoelus*, similar to the *Brontosaurus*. Chunks of the Paluxy's rock riverbed containing tracks were cut out in 1940 and sent to New York's American Museum of Natural History and Texas universities. Fossil reptile expert Roland T. Bird brought the tracks to wide attention with a 1954 *National Geographic* article. (Courtesy Don and Vivian Hill Collection)

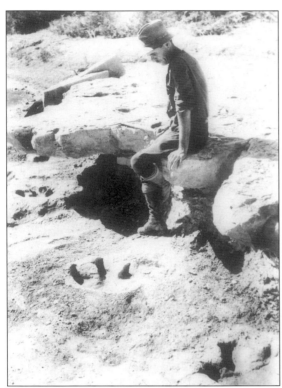

Roland T. Bird admires some of the dinosaur tracks he helped unearth, funded by a WPA project. (Courtesy Roland T. Bird Collection; Dinosaur Valley State Park)

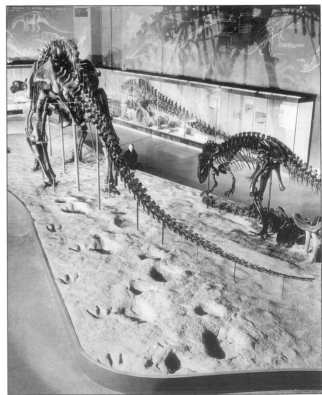

Here is the Paluxy Trackway of dinosaur tracks as displayed at the American Museum of Natural History in New York. (Somervell County Museum)

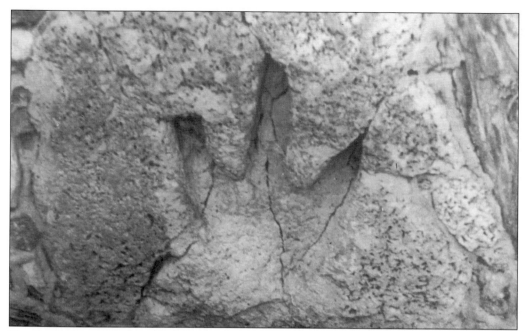

To admire this track, visit the bandstand on the square. Dug up in the 1930s, this one became the "verdict" track, likely a 20 to 30 foot *Acrocanthosaurus*, predecessor of *T. rex*, used world-wide by paleontologists to compare other tracks of similar species. Note the very good knothole in the petrified wood. (Somervell County Museum; Dr. N. C. Dougherty photo)

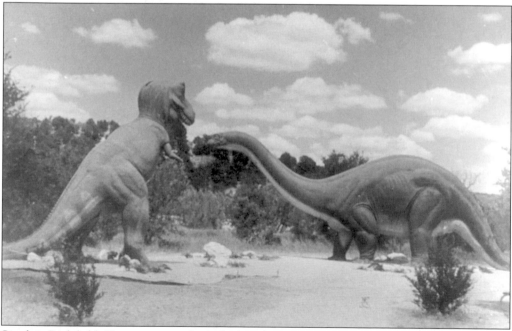

Sinclair-Richfield Corporation, which had a dinosaur on its logo, donated these 70 foot *Apatosaurus* and 45 foot *Tyrannosaurus rex* replicas to Dinosaur Valley State Park after being shown at the New York World's Fair 1964-5. Opened in 1969, the park preserves a trail of tracks for future generations. (Roland T. Bird Collection; Dinosaur Valley State Park)

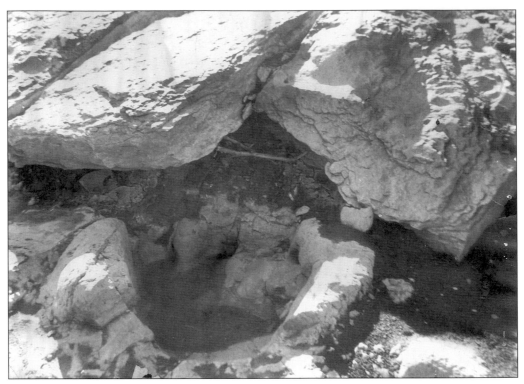

Here is a very good example of the huge tracks made by plant-eating, 70 foot-long *Pleurocoelus*, who squished their clawed, 4-toed hind feet in the mud millions of years ago. (Somervell County Museum; Dr. N. C. Dougherty photo)

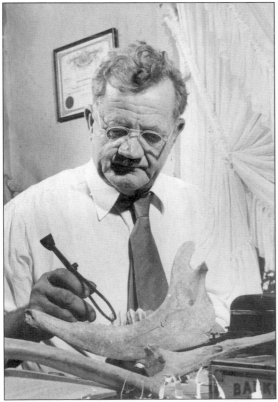

Ernest Tolbert "Bull" Adams was one of the most remarkable men to ever come out of Somervell County. His feats of strength and intellectual abilities are legendary. He graduated with a degree in classical languages from Baylor University in 1911, and then as a Rhodes scholar, attended Oxford University in England for two years earning a degree in jurisprudence. A brilliant, compassionate attorney, he spent most of his time, though, exploring Somervell County, finding artifacts and cataloguing sites of the prehistoric man as well as dinosaur track excavation. He also served as Assistant Curator of the Red Man Division, John Kern Strecher Museum at Baylor University. (Photo courtesy of Mary Adams)

Three
HIGHWAYS AND LIFEWAYS—SCENES OF OLD GLEN ROSE

There is nothing like hiking in the Glen Rose hills on a Sunday afternoon. (Ruby Gresham Leach Collection)

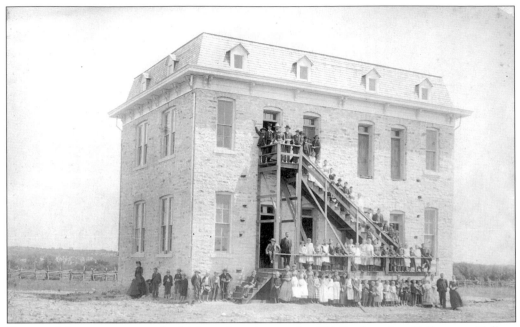

Young adults went upstairs for higher education at the Old Presbyterian College on College Street, c. 1890. This location is presently the Glen Rose Junior High campus site. (Ruby Gresham Leach Collection)

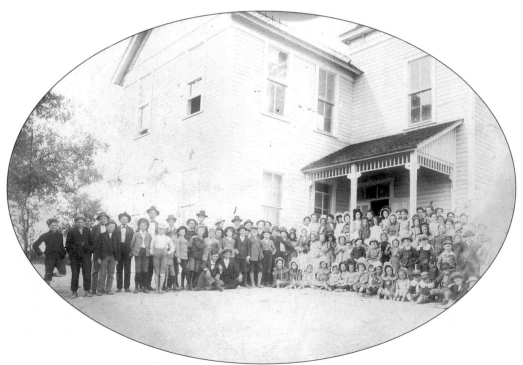

Students are pictured taking a break from the three Rs at the Glen Rose public school, February 1902. The building was located at the corner of Vernon and Live Oak and later became the Cliff Hotel. (Somervell County Museum; Bertie Dempsey Reeves photo)

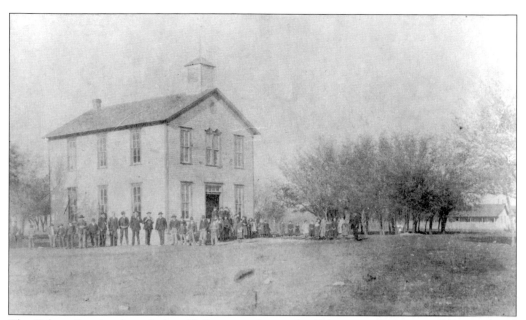

The Paluxy Baptist Association College stood near the Paluxy, at the corner of Barnard and Van Zandt in the location of a bygone village known as Springtown. (Courtesy Booker Family)

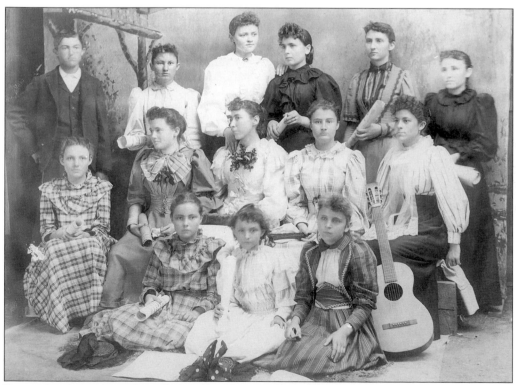

Pictured is the singing class of 1893–94. (Somervell County Museum)

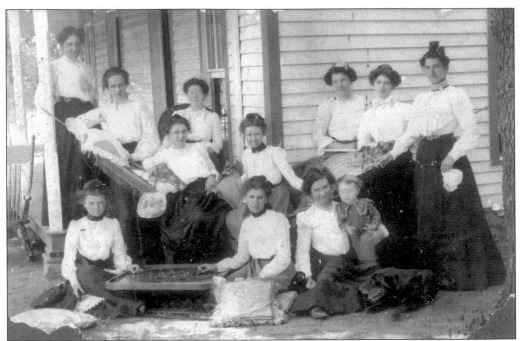

Here are some society gals at the Gresham home, c. 1900. Seated on the ground, from left to right, are Lela Gresham (Edmiston), unidentified, and Cora Lilly holding an unknown toddler; (middle row) Ruby Gresham (Leach) in hammock, unidentified, Lora Lilly, unidentified, and unidentified; (back row) Hattie Gresham, unidentified, and Dora Lilly (Goldsmith) next to the window. The Lilly and Gresham families were local merchants and neighbors on the bluff. (Special permission of Johnny Goldsmith; photo at Somervell County Heritage Center)

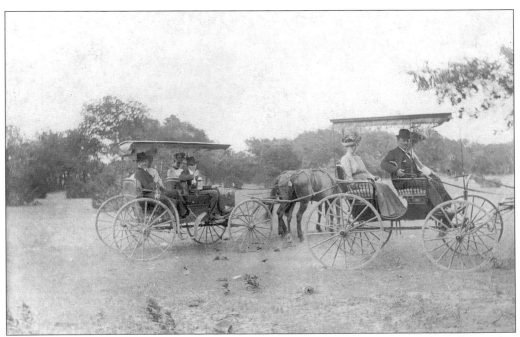

Seeing the sights on a buggy ride, dating Victorian style. (Ruby Gresham Leach Collection)

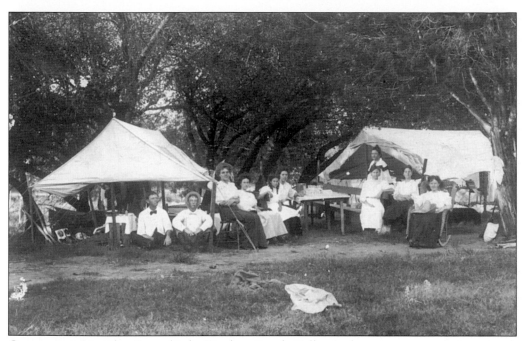

Gone campin' in Glen Rose. (Ruby Gresham Leach Collection)

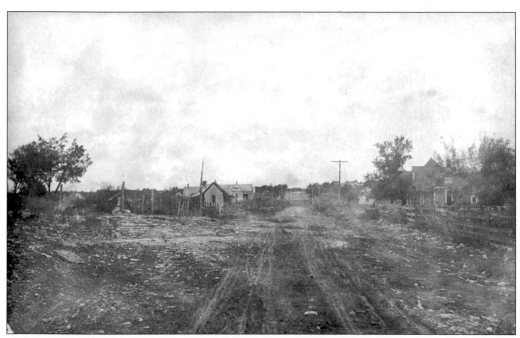

Pictured is Hereford Street, seen just after the 1902 tornado that gave the avenue its nickname, Cyclone Street. It is also called Paluxyville Road. (Ruby Gresham Leach Collection)

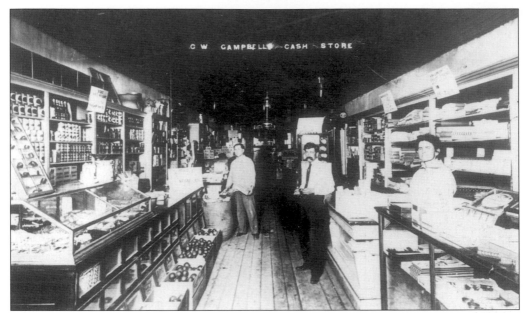

Here is Lilly Hill Campbell, at right, in Campbell's Cash Store on the square. Clarence W. and Lilly Campbell, two of Glen Rose's most energetic promoters, contracted for the printing of many of the postcards in this book. Eventually, the card collection was handed down to Don and Vivian Hill, and in 2001, Dorothy Jo Osborn was the keeper of the cards. (Somervell County Historical Society)

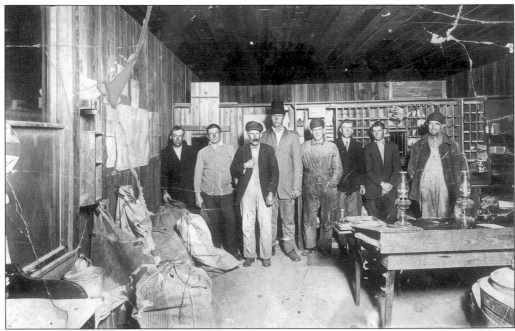

Through rain, sleet, and...sulphur water? This is the post office on the north side of the square, 1915. Pictured, from left to right, are an unidentified man, postman Pete Lilly, postman Mr. Griffith, postman George Adams, Arthur Gribble, clerk Jack English, Luck Merrill, and postman Mr. Boyd. (Somervell County Museum; Hattie Embree Polly photo)

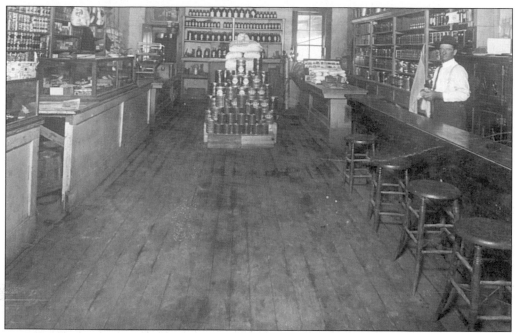

Jim Lilly is captured on film inside his store on the square. (Courtesy of Mary Lee Bridges Lilly)

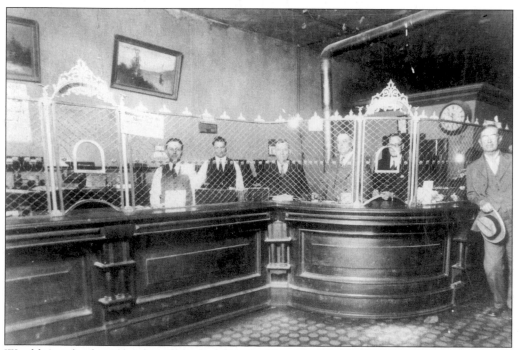

Wouldn't it be fun if banks still looked like the First National in Glen Rose? Left to right, in this photo, are Coll Milam Jr., Wayne Hart, unidentified, C.A. Bridges, (?) Robb, Judge S.G. Tankersley, c. 1928. (Somervell County Historical Society)

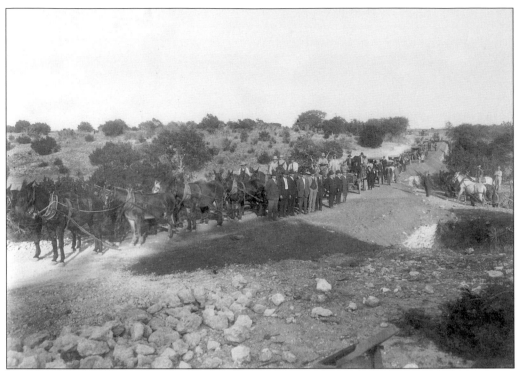

Building the road to Cleburne. (Somervell County Historical Commission; Connally Collection)

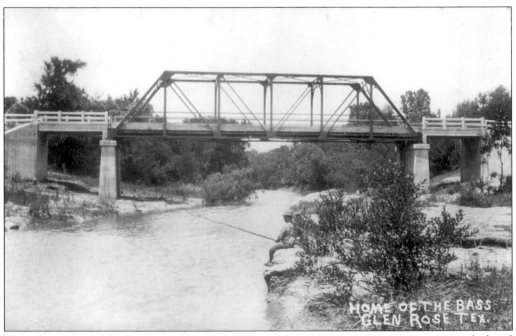

This postcard is of the bridge built over Squaw Creek in 1922 and the next six postcards detail the "new road" from Cleburne to Glen Rose (current Van Zandt Rd./CR 312) that promoters hoped would boost the economy. (Don and Vivian Hill Collection)

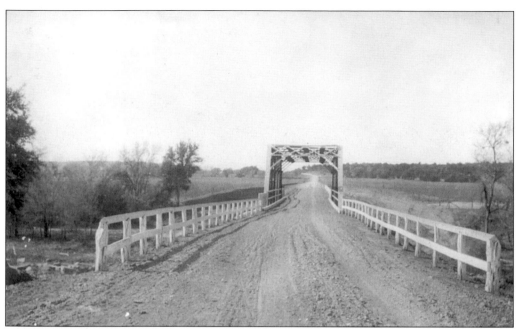

This is Squaw Creek bridge near Tres Rios looking toward town. (Don and Vivian Hill Collection)

Curving with the Paluxy. (Don and Vivian Hill Collection)

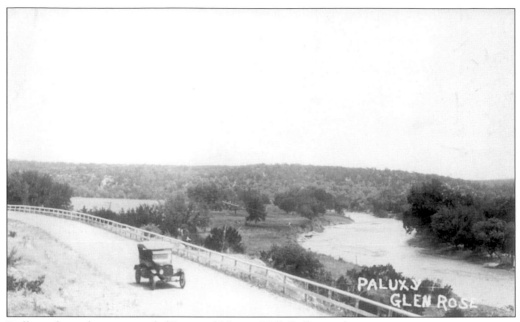

Rolling along the river road. (Don and Vivian Hill Collection)

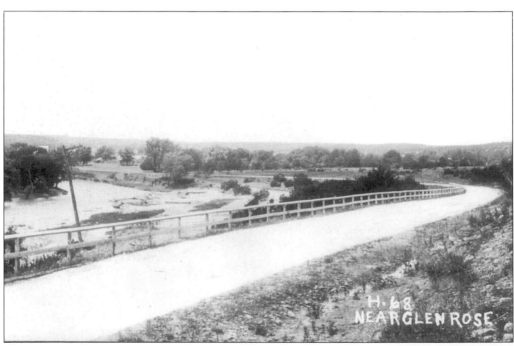

This view looks toward what we now call the Old Rodeo Grounds. (Don and Vivian Hill Collection)

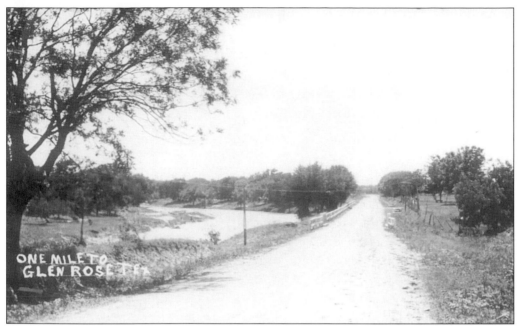

Here is Van Zandt Street, looking toward town. (Don and Vivian Hill Collection)

This view is of Barnard Street, curved near today's Community Center, headed toward town. (Don and Vivian Hill Collection)

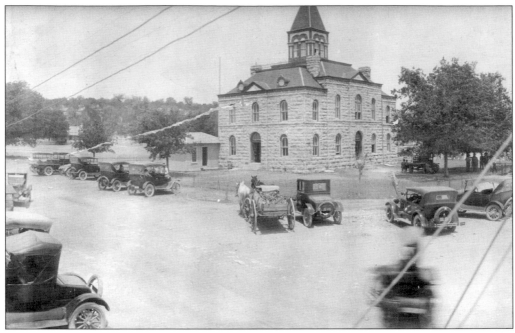

Here is a panorama of downtown, 1925. (Courtesy of Nancy Bridges Keese; photo originally hung in First National Bank where the Bridges family worked.)

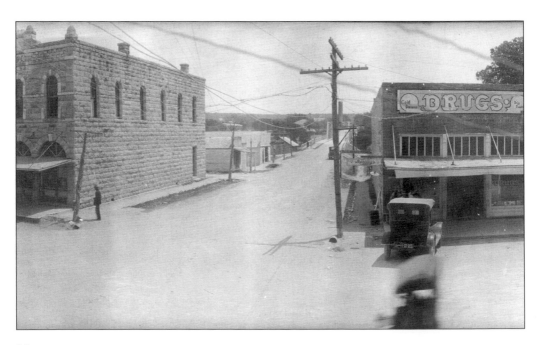

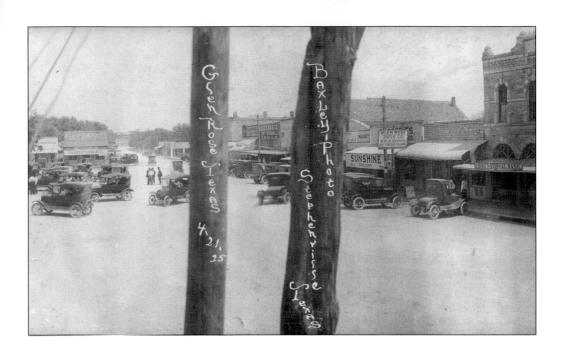

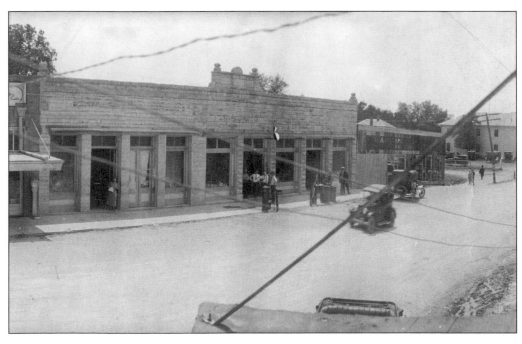

Glen Rose Texas

THE FAMOUS HEALTH & PLEASURE RESORT

ISSUED BY THE
GLEN ROSE CHAMBER OF COMMERCE
JUDGE S. G. TANKERSLEY, President
F. B. KIRBY, Secretary

Just the facts, ma'am. This is a Glen Rose promo c. 1925. (Somervell County Museum)

Glen Rose, Texas

Somervell County

Glen Rose is one of the most picturesque spots in the Southwest. It is easily accessible by way of Cleburne, Walnut Springs, Granbury and Stephenville.

A regular "Jitney" service is maintained from the above points to Glen Rose Daily.

Glen Rose is situated on the banks of the Paluxy, an ever-flowing stream of clear water, winding in and out among the cedar-covered hills, presenting an expanse of varied scenery attractive to the eye as any that may be found by thousands of miles of travel.

Glen Rose is fast becoming one of the most popular summer resorts of all the Southwest.

Accommodations are offered to those who desire to camp, in the way of Camp Cottages in the various parks, furnished with benches, Tables Cook Stoves and wood, you need only to bring some bedding and a few simple cooking utensils and you are equipped for a rousing good time, for weeks, or, even months.

This is the day of autos. Ninety percent of the recreations or summer vacations are now taken by auto. It does not matter whether you

are within 25 or 200 miles of Glen Rose, a few hours drive will land you in Glen Rose.

Plenty of the best water in America to drink, the finest bathing to be found, beautiful, shady evening driveways, and as hospitable a people as ever you cast your lot with.

The merchants of Glen Rose make special efforts to equip themselves for the needs of the summer visitors, making it unecessary for you to load your cars with the commodities that can be furnished as cheap or cheaper than at home. Glen Rose has several Hotels and Rooming houses and several Cafes that would be a credit to a much larger town, and vie with each other in point of service, with prices within reach of all.

While Glen Rose has many attractions the thing superlative is her waters. It was left to the United States Government some years ago to visit all the watering places of America and reduce their findings to minute analysis. We find this report in the Government report at Washington, D. C. "For medicinal purposes these waters are valuable, and on analysis are found to be more nearly identical with the analysis of the waters of Carlsbad, Germany, than any other water found in the United States."

No comment we could make could add to or detract from this statement. The waters of Carlsbad, Germany, have for centuries acquired a world reputation, and this statement by our Government unfolds to us the unparalelled possibilities of these waters.

AMUSEMENTS

The public is advised that Glen Rose has Movies, with the latest pictures being shown each week. Also Dance Halls of an unlimited capacity and a fine Skating Rink.

CHURCHES

The Methodist, Baptist and Christian churches invite you to their churches while in Glen Rose.

A new two-story modern brick school building accomodates our children and in which there is ample room for yours.

GLEN ROSE NEEDS—

A Modern 200 Room Hotel.—

More Parks of greater dimensions, to keep pace with the rapid development of this Resort.

A Dam across the Paluxy to convert her limpid waters to the comfort and pleasure of the throngs that visit here.

1,000 Small farmers to develop our Truck, Dairy and Poultry interests—Great possibilities.

The South, and Texas especially to know the value of our WHITE SULPHUR WATER.

GLEN ROSE HAS—

200 Flowing White Sulphur Wells.

The Paluxy River that never fails to flow.

A Court House, also a Jail without inmates.

10 Beautiful Parks, 200 Camp Houses.

Scenery that rivals Colorado, or the Cascade Mountains.

State Highway 68 from Dallas via Cleburne.

A contented, happy population invites YOU to join—on the way to greater development.

We think the best spot in our Nation for HEALTH.

Paluxy Valley has approximately 200 or more flowing wells, pouring forth streams of white sulphur, containing the properties indicated by the above analysis. If it has not been your fortune to pay Glen Rose a visit, spend your vacation here this summer and hereafter you will need no one to tell you where to recreate.

Glen Rose is fast becoming famous as a health resort, and is perhaps the only town of its age in the state that can boast that it has NEVER had a case of Typhoid Fever to develop in it. Physicians over the state are now recommending its curative waters for Stomach, Liver, Kidney and other complaints.

A generous competence combined with health with an active pardticipation in the affairs of life, demand a reasonable recreation during the heated months. Get this recreation and renewed vigor for the strenuous duties of heavy fall work by taking the family and your associates to "Nature's Beauty Spot," Glen Rose. Here you have a good "country time". Wade in the limpid waters of the Paluxy. Here you will find associates of refinement and culture nestled in every nook and corner along its shady banks.

You can make no mistake in spending your vacation in this beauty spot, where the old and young alike, enjoy every minute of the time; where the over-worked and weary come for complete rest and recuperation, and where the fun loving come for enjoyment.

TRY IT ONCE, WHY NOT?

Glen Rose is just now coming to be appreciated by those seeking permanent homes, which is evidenced by the recent numerous purchases and the increased deposits in our banks.

If you are looking for a home where you can get all the comforts of a quiet country life, yet live in town, come to Glen Rose and look it over, and hear the wonderful stories.

You will enjoy the fresh garden vegetables that grow in the irrigated gardens of the Paluxy Valley. If your appetite is gone, you will grow hungry passing one of these gardens. Fresh melons, as delicious as the famous "Georgia Sweets" that bring a dollar each in New York, are found here fresh from the vine each morning at prices so modest it causes you to blush.

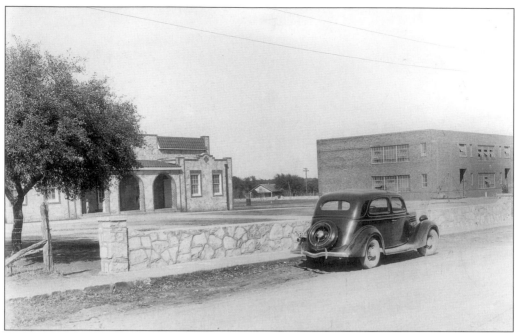

Here is an example of the Glen Rose schools in the 1930s. The brick building replaced the Presbyterian College building in the 1920s; the rock building was built as a WPA project in 1935. (Courtesy of Jerry Dan Osborn)

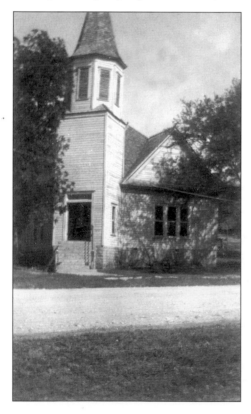

The First Baptist Church on Barnard Street was built in 1905. (Don and Vivian Hill Collection)

Pictured is the First Christian Church on the corner of Shepard and College Streets. (Don and Vivian Hill Collection)

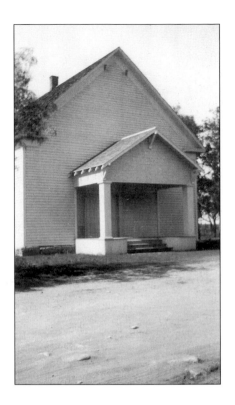

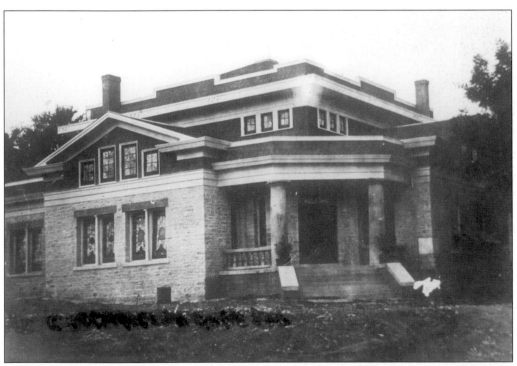

Here is the First Methodist Church, one block from the square and built in 1915. (Somervell County Historical Society)

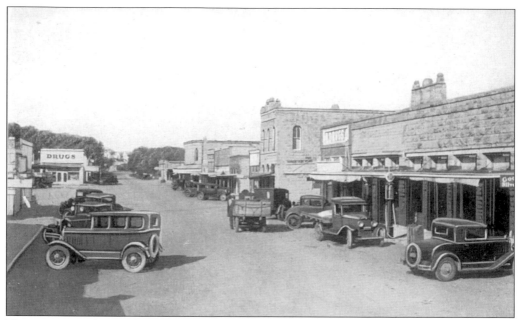

This is a view of Main (Barnard) Street, looking north. (Don and Vivian Hill Collection)

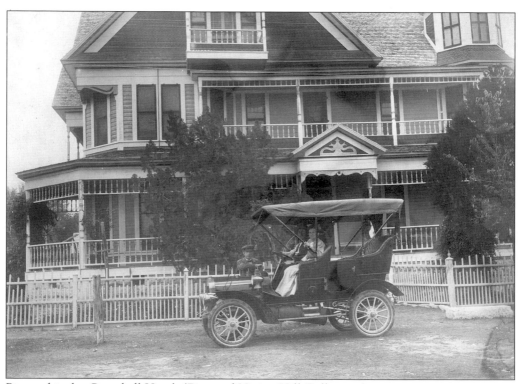

Pictured is the Campbell Hotel. (Don and Vivian Hill Collection)

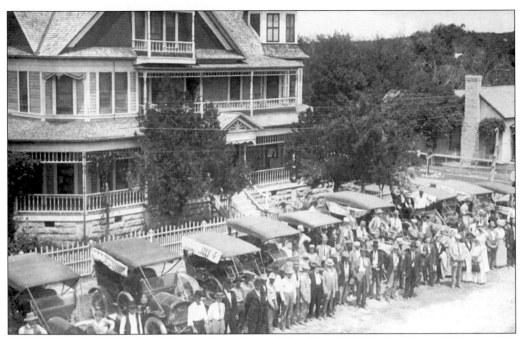

Ready to roll in a Fourth of July parade in front of the Campbell Hotel. (Don and Vivian Hill Collection)

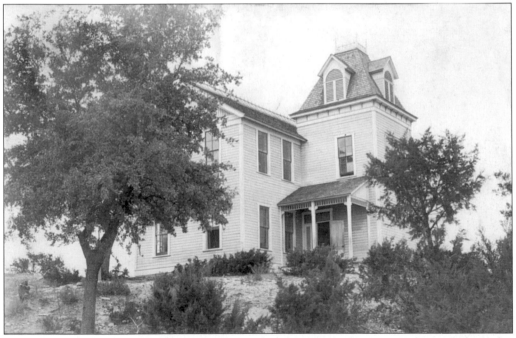

The Cliff Hotel, once a Glen Rose school, stood at the corner of Vernon and Live Oak until it burned in the 1920s. (Ruby Gresham Leach Collection)

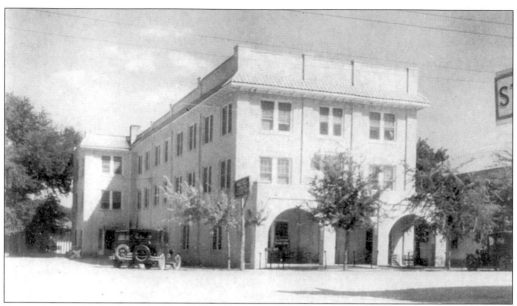

Recently restored, the Glen Rose Hotel on Barnard Street still stands. (Ruth F. Parker Collection; Booker Family photo)

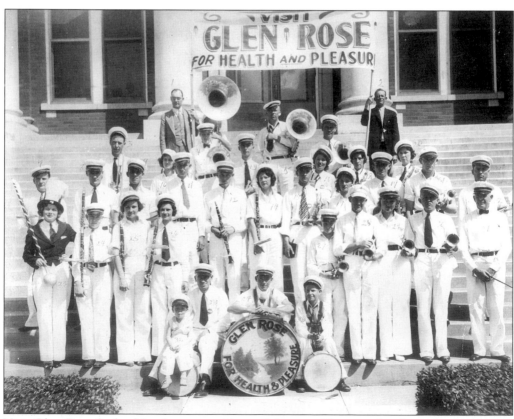

Visit Glen Rose for health, pleasure, and beautiful music. The town band was directed by J.F. Allen in 1932. (Somervell County Museum)

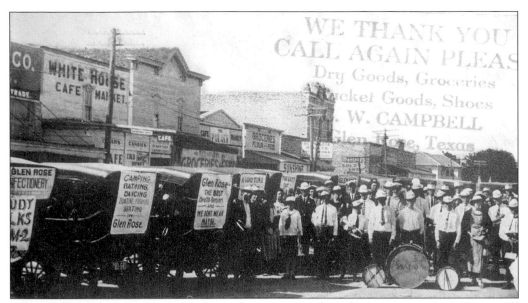

"The best health resort" boosters take to the streets, "and we don't mean maybe." (Somervell County Museum)

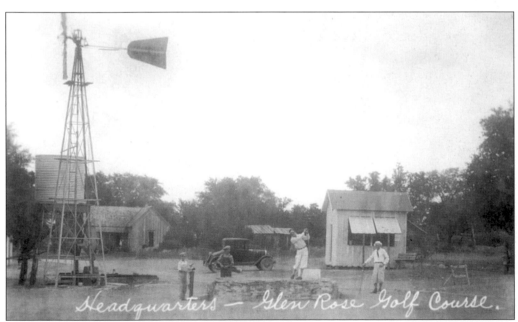

After a bracing gulp of sulphur water, Glen Rose visitors could hit the links, built by G. I. Daniel. Pictured is the Glen Rose Golf Course Headquarters. (G. I. Daniel Family photo)

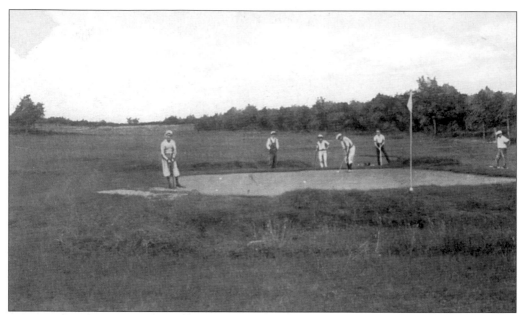

Putt putt. (Somervell County Museum)

This is a view from the sixth tee. (Somervell County Museum)

Hole in one? Ed and Mary Elizabeth Daniel, the course's part-owners, practice putting. (Courtesy of G. I. Daniel Family)

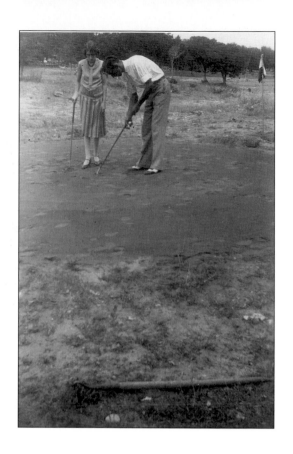

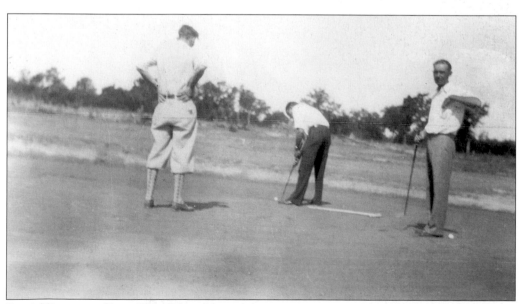

Fore! (Courtesy of Jerry Dan Osborn)

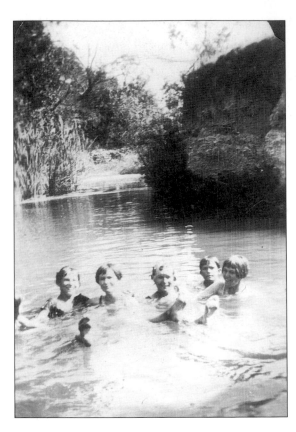

A splashin' good time at Lane's swimmin' hole on Wheeler Branch, 1920s. (Courtesy of Maxie Leach)

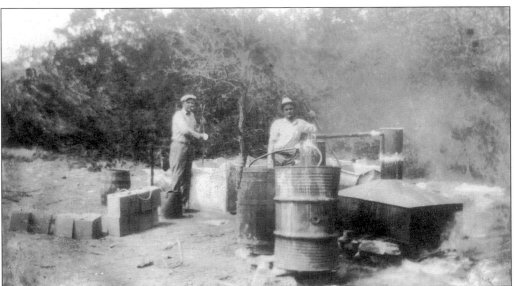

The lives of most area folks, of course, centered on hard work, school, church, and innocent recreation. But during Prohibition and the Great Depression, some put the local sulphur water to work, "makin' shine" and "makin' money." The local white lightnin' earned Glen Rose the title, "Moonshine Capital of Texas." (Courtesy of Brenda Buzan Ransom; Lloyd Don Moss Collection)

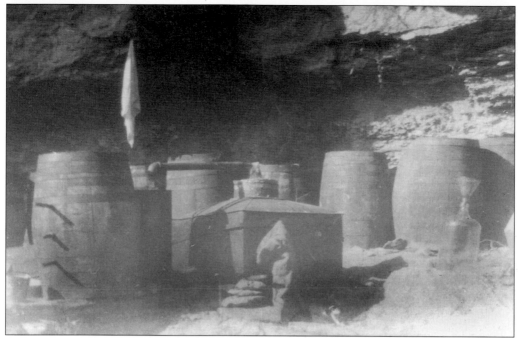

A Saturday night's supply. The Somervell hooch may have had its own healing powers. Houston journalist Sigman Byrd wrote that his family visited Glen Rose yearly and "drank deep from and bathed long in each and every therapeutic fountain," a tradition that kept them "healthy as horses." Only Byrd's Uncle Larry refused the mineral brew, guzzling the bootlegger's best instead. When World War II broke out, Uncle Larry was the only Byrd deemed fit enough to serve his country. Working stills were virtual Appalachian distilleries. (Somervell County Museum)

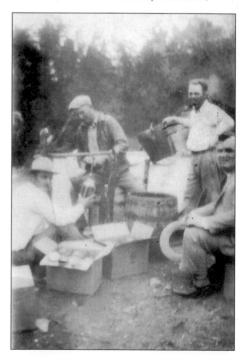

Here are moonshiners packing fruit jars full of 'shine in cardboard boxes for shipment. (Courtesy of Brenda Buzan Ransom; Lloyd Don Moss Collection)

51

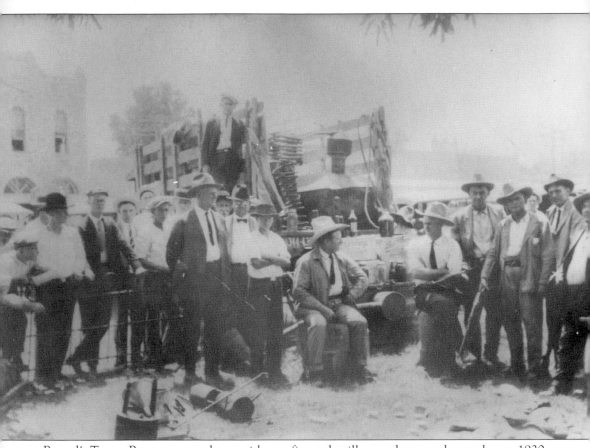

Busted! Texas Rangers pose here with confiscated stills on the courthouse lawn, 1920s.
(Somervell County Museum)

Four

PALUXY—A RIVER
RUNS THROUGH

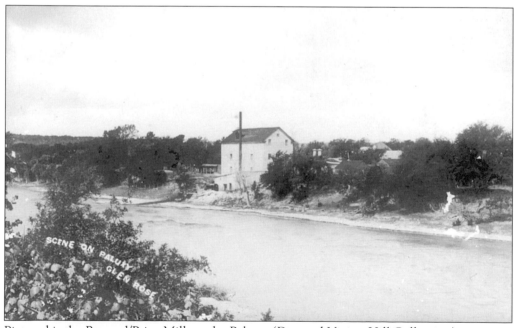

Pictured is the Barnard/Price Mill on the Paluxy. (Don and Vivian Hill Collection)

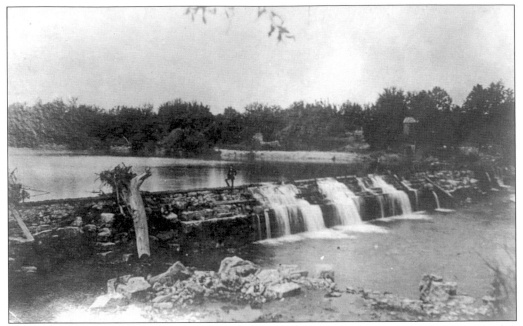

Here are Barnard's Mill dam and pond in the late 1800s. (Ruby Gresham Leach Collection)

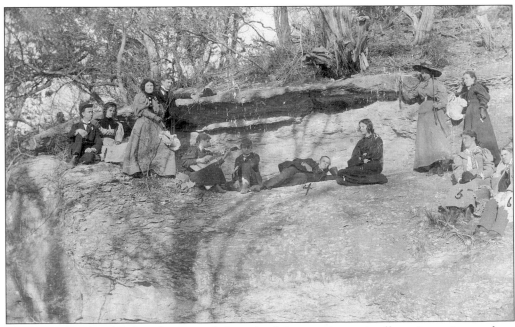

The normally placid Paluxy has provided much of the town's scenic allure since pioneer days. These folks, decked out in their Sunday best, enjoy a little guitar music on its rocky banks around 1892. (Ruby Gresham Leach Collection)

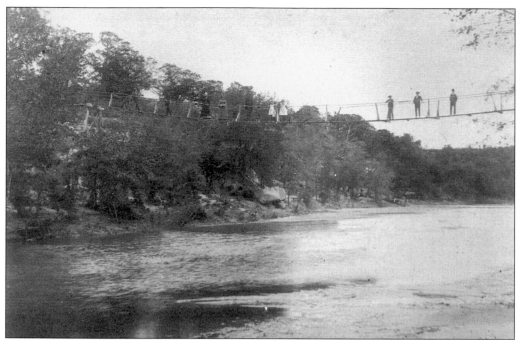

Daring dudes cross the Paluxy on a swinging bridge at the east end of town in the early 1900s. (Special Courtesy of Johnny Goldsmith; photo at Somervell County Heritage Center)

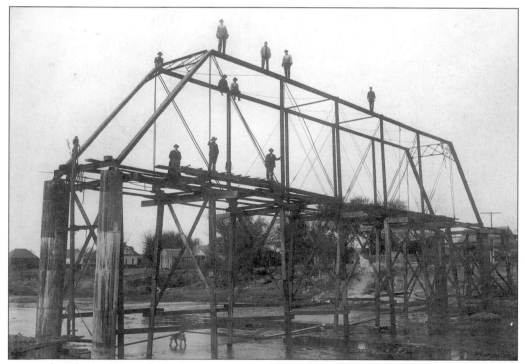

Pictured is the building of the first in-town bridge over the Paluxy. Access to town from the south and east was where Hereford Street comes to the river. Fording the river proved to be frequently hazardous with the whims of Paluxy's swift rises. (Somervell County Museum)

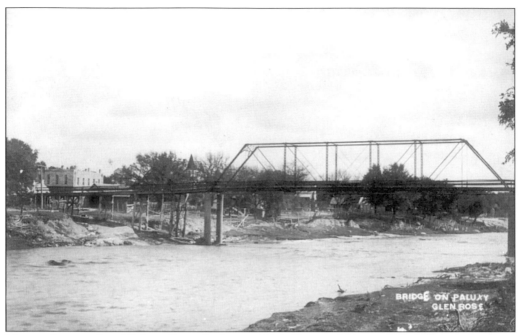

Here is the completed Paluxy River Bridge, c. 1906. (Don and Vivian Hill Collection)

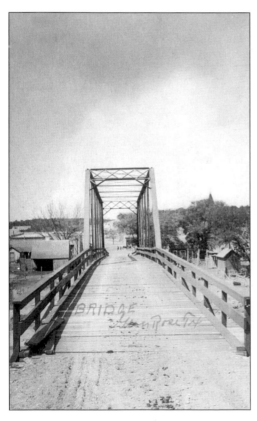

Heading across the bridge towards the town square. (Don and Vivian Hill Collection)

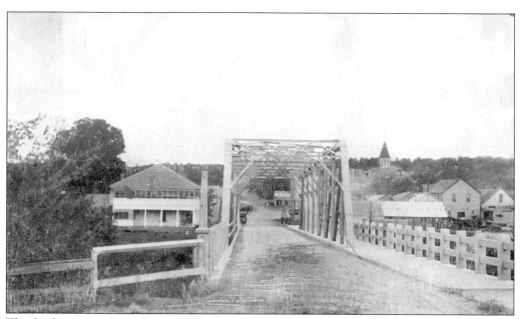

This bridge scene shows Dr. Snyder's first sanitarium on the left and the courthouse tower on the right. (Don and Vivian Hill Collection)

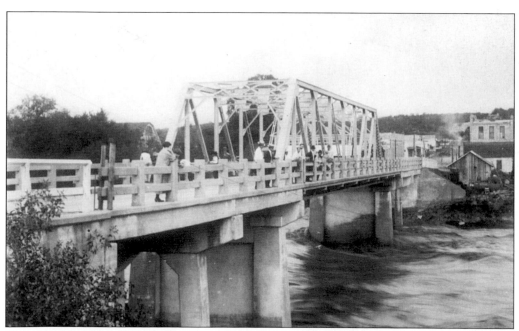

This view is of the same bridge after a renovation in the 1920s. The Paluxy River is on a rampage. (Don and Vivian Hill Collection)

Let it snow, let it snow, let it snow. Streaks in the snow are probably "well branches" of flowing sulphur water from riverside artesian wells. The smokestack of a mill/gin can be seen in the distance. (Courtesy Booker Family)

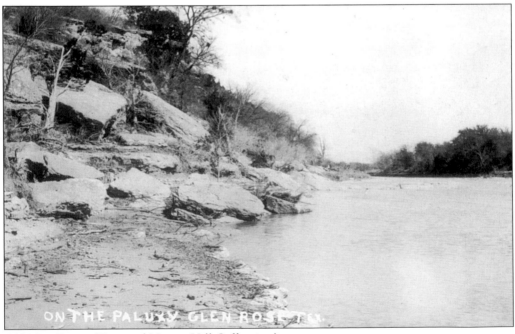

Old Man River. (Don and Vivian Hill Collection)

The imagination can run wild pondering the origin of Lover's Leap. A white cross sits atop the bluff behind present Glen Lake Methodist Camp. (Don and Vivian Hill Collection)

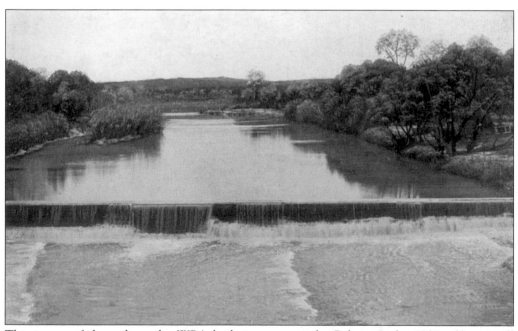

This is one of three dams the WPA built in town on the Paluxy in the 1930s. (Somervell County Museum)

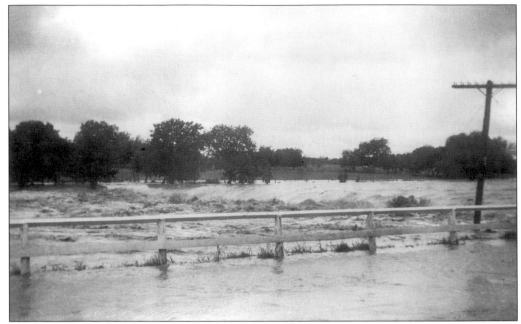

This is a photo portraying what happens when nature gets cranky. The Paluxy is shown on a rampage in 1935 across the road from Oakdale Park. (Somervell County Museum)

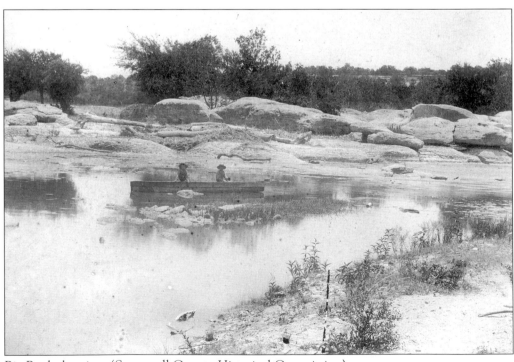

Big Rocks boating. (Somervell County Historical Commission)

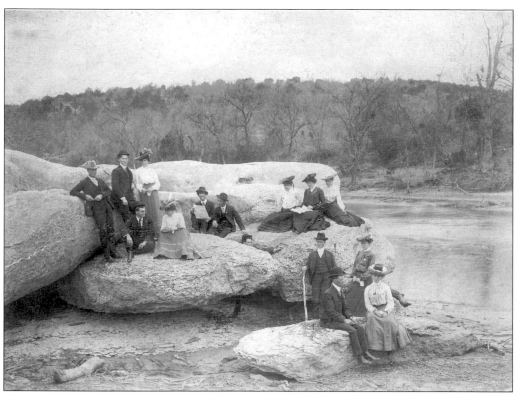

This is another riverside outing, at the local landmark called Big Rocks. These boulders can be seen on Barnard northeast of downtown, now called "Big Rocks Park." (Somervell County Museum)

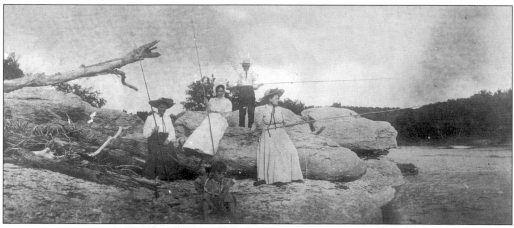

You get a pole, and I'll get a line—fishing at Big Rocks in 1906. (Ruby Gresham Leach Collection)

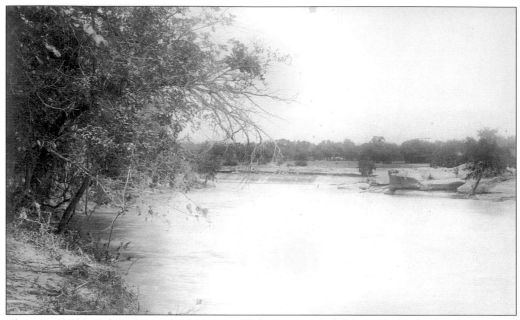

This is an 1880s Paluxy scene, looking toward the present Oakdale Park. (Ruby Gresham Leach Collection)

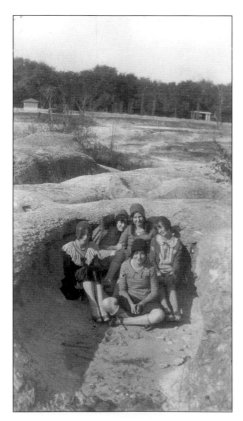

How many Glen Rose gals can fit in the "Queen's Bathtub" at Big Rocks? Gwendolyn Gibbs (McLemore), Mildred Davis, Veda Mae Dye (Giesecke), Janette Gibbs (Chambers), and Emily Davis find out in the 1920s. (Courtesy of Maxie Leach)

Five

PARKS

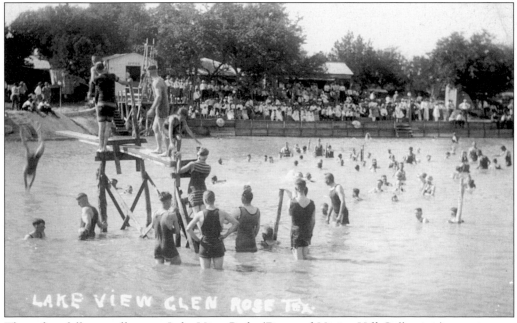

These fine folks are all wet at Lake View Park. (Don and Vivian Hill Collection)

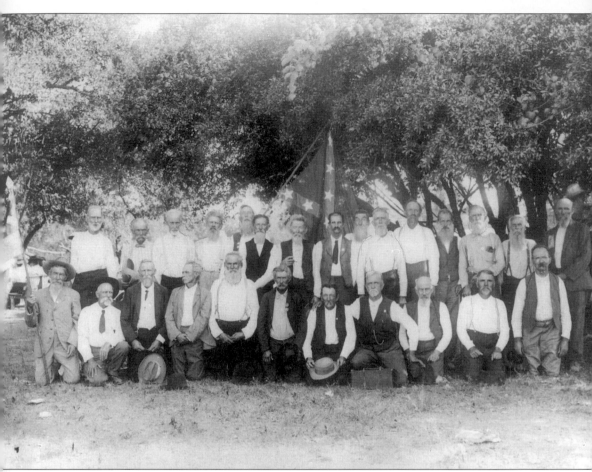

It could perhaps be said of Glen Rose that the town had more parks per capita than any other Texas town. Here, at the Rufe Wood Camp, United Confederate Veterans gather for a reunion at Moore's Park, a few miles up the Paluxy, *c.* 1900 or later. Pictured, from left to right, are(front row) E. A. Mosely, George L. Booker, J. W. Bolton, B. C. Ferris, Henry Weddle, Jim Wilkerson, R. D. Holder, L. M. Winburn, James Beck, Dave P. Garner, and (?) Plummer; (back row) unidentified, Gray Jordan, J. M. Sims, J. H. Green, W. B. McFaddin, W. M. Martin, G. B. Lewis, W. L. Lilly, William Shipman, Don Sawyer, unidentified, J. A. Hamberlin, W. M. Martin, and C. C. McCaghren. (Somervell County Museum)

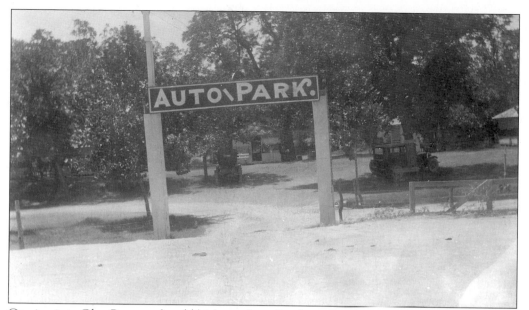

Coming into Glen Rose on the old highway from Stephenville, the Auto Park was the first park you saw along the river. (Don and Vivian Hill Collection)

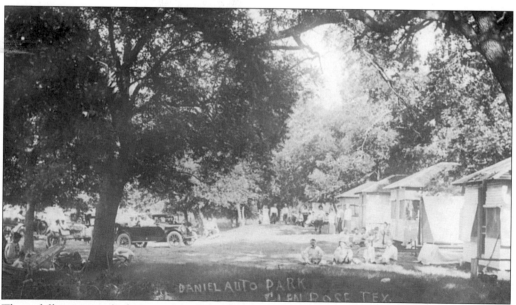

These folks pose with their autos at Daniel's Auto Park. (Don and Vivian Hill Collection)

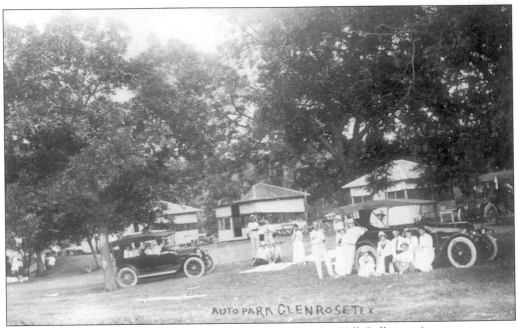

Autos turn in here. Daniel sold to Bridges. (Don and Vivian Hill Collection)

All the cabins in the popular Auto Park were named for various American states. (Don and Vivian Hill Collection)

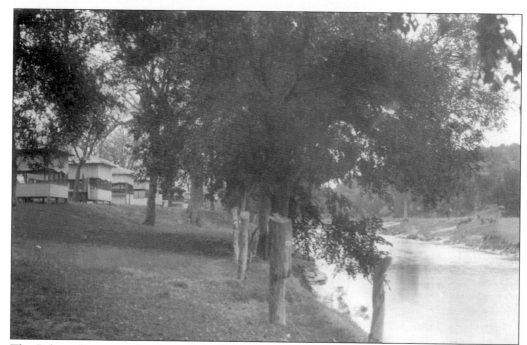

The Paluxy flows past the Auto Park. (Don and Vivian Hill Collection)

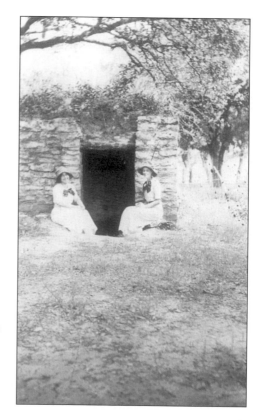

Nanny's Park started as a place for people to camp when bringing their corn to the mill. This is the Ice House in Nanny's, which later became Pruitt's Park and then Rivercrest Park. "They would chop ice out of the mill pond and pack it in hay for summer," says Dorothy Leach. (Ruby Gresham Leach Collection)

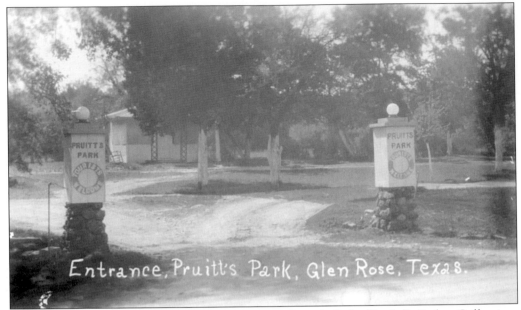

Entrance, Pruitt's Park, Glen Rose, Texas.

"Tourists Welcome" says the sign on the gates at Pruitt's Park. (Ruth F. Parker Collection; Booker Family photo)

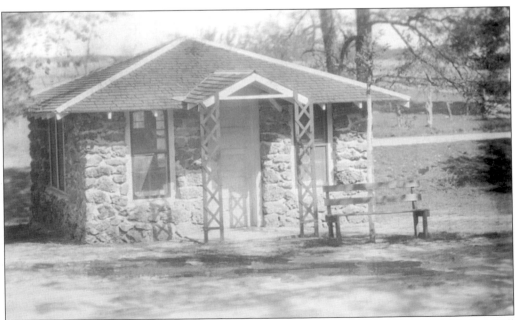

Pictured is a Pruitt's Park cabin of cobblestone and petrified wood. (Don and Vivian Hill Collection)

This is a photograph of Dr. E. B. Earp's home and office. Cabins in Pruitt/Rivercrest Park had names like Roll Inn, Walk Inn, Sleep Inn, Creep Inn, Tumble Inn, Wobble Inn, Sneak Inn, Dewdrop Inn, Get Inn, Be Inn, Never Inn, Jump Inn, Run Inn, Peek Inn, Fall Inn, Stop Inn, Stay Inn, Love Inn, and Butt Inn. (Don and Vivian Hill Collection)

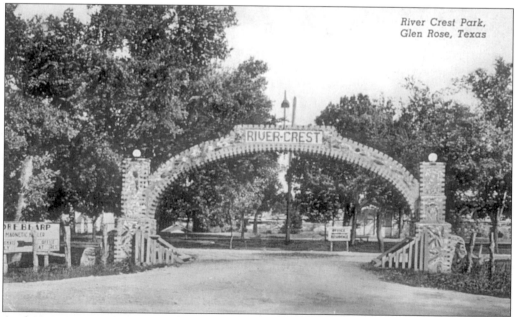

As the sign says, Dr. E.B. Earp offered magnetic healing treatments to folks who passed beneath the beautiful petrified-wood arch at Rivercrest Park. (Ruth F. Parker Collection; Booker Family photo)

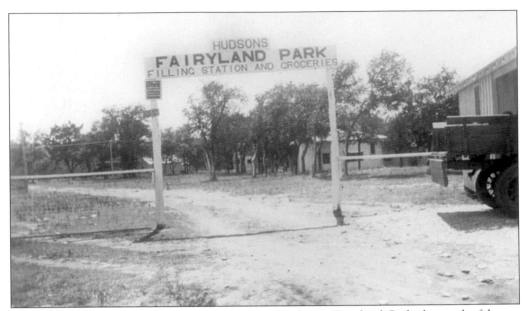

Across the Paluxy from Rivercrest, visitors to Hudson's Fairyland Park dreamed of happy waters. (Don and Vivian Hill Collection)

Fairyland scene. (Don and Vivian Hill Collection)

Fairyland scene. (Don and Vivian Hill Collection)

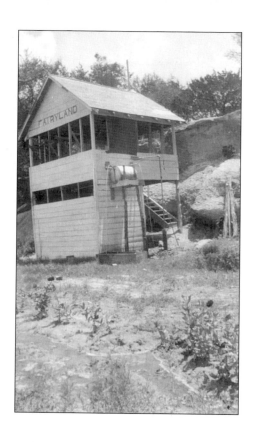

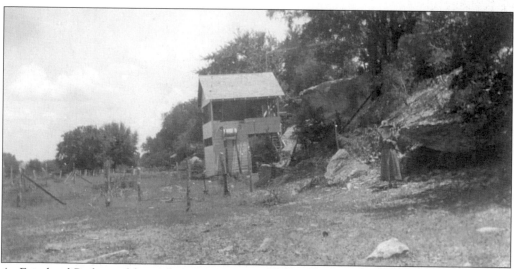

At Fairyland Park, earthly needs were not ignored. (Don and Vivian Hill Collection)

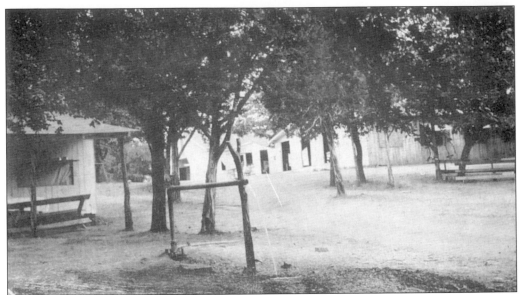

Known in earlier days as Amusement Park, Matthews Park, and Mule Barn Park, it is now the site of today's Heritage Park. (Ruby Gresham Leach Collection)

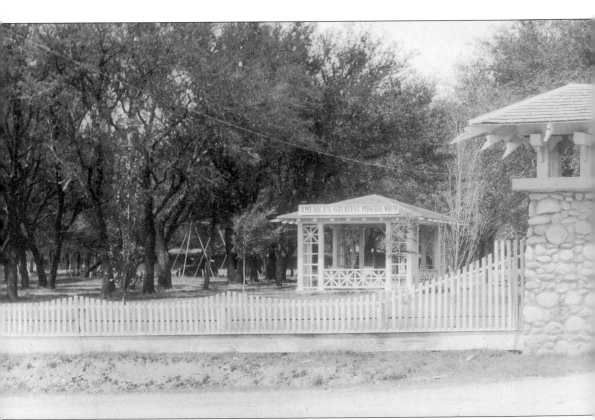

"Let me place a well of Healing Waters by the side of the Road and thus be a friend to man," was written on the gazebo in this panorama photo of Oakdale Park at one time and "America's

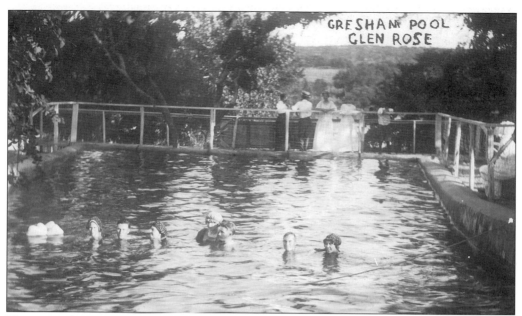

The tranquil artesian waters of Gresham Pool were on the bluff above Barnard Street. (Don and Vivian Hill Collection)

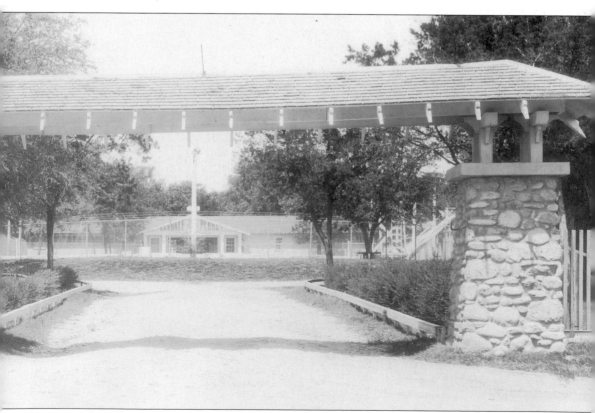

Greatest Mineral Waters" at another. The casino at the far right was a bar with dancing and then later a skating rink. (Don and Vivian Hill Collection)

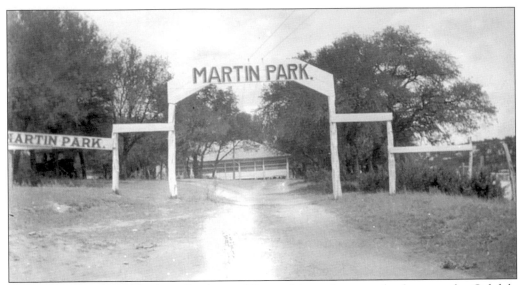

The entrance to Martin Park, at Gaither and Barnard, is on the grounds of present-day Oakdale Park. (Don and Vivian Hill Collection)

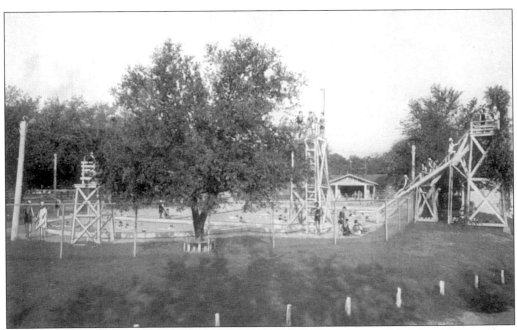

This early Oakdale Park view shows the lifeguard tower, diving tower, and slide with water from a flowing well running down it. (Don and Vivian Hill Collection)

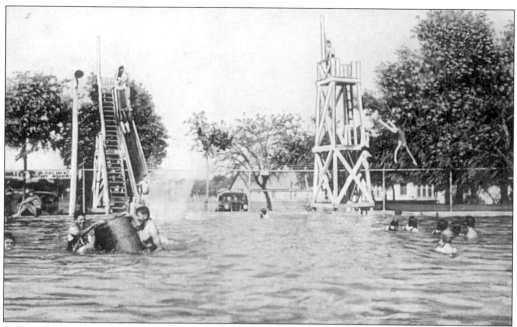

Taking the Oakdale Plunge. Dug by mule power in 1925, the 300,000-gallon Oakdale Plunge is still in business. From here, water frolickers could gaze across the Paluxy upon the soaring cliff of Lover's Leap. (Ruby Gresham Leach Collection)

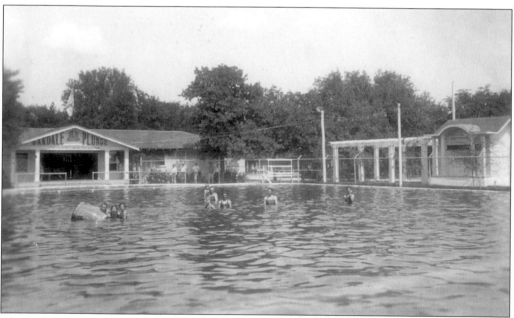

The building at the far right of this Oakdale pool view played music for swimmers. (Don and Vivian Hill Collection)

Cleburne journalist O.C. Poole kept a private cabin in Glen Rose he called Toad's Place. (Don and Vivian Hill Collection)

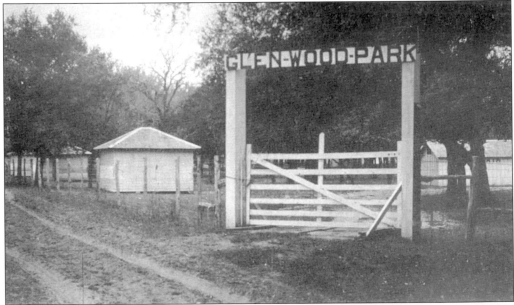

Glenwood Park, also known as McAllister Park, between present-day College and Holden Streets, was back in the woods. The site is now partly residential and also part of the Glen Rose Medical Center complex. (Don and Vivian Hill Collection)

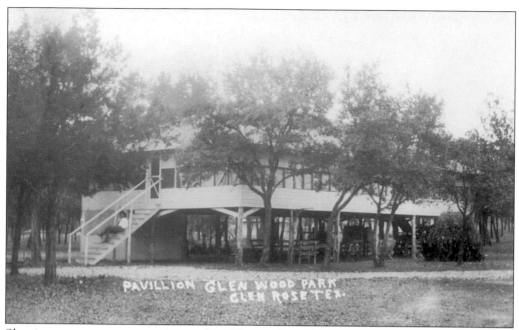

Sleeping quarters were upstairs at this Glenwood pavilion, so guests could enjoy a breeze rustling through the trees. (Don and Vivian Hill Collection)

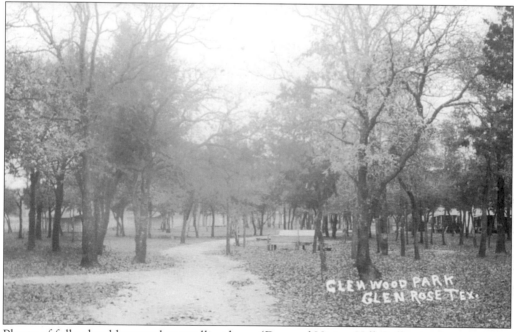

Plenty of folks should remember strolling here. (Don and Vivian Hill Collection)

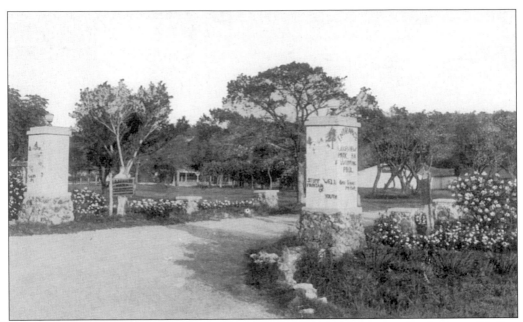

A most inviting gateway at Lake View Park: "Lakeview Park & Swimming Pool; Stump Well—Fountain of Youth." This park is presently Glen Lake Methodist Camp. (Ruth F. Parker Collection; Booker Family photo)

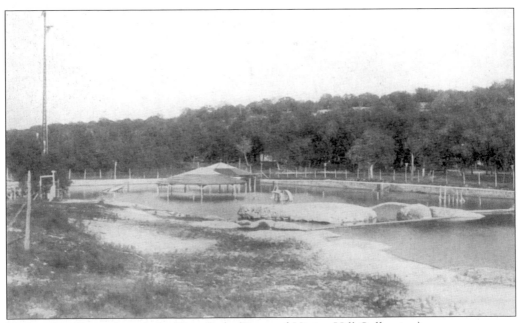

Under a big Texas sky at Lake View Park. (Don and Vivian Hill Collection)

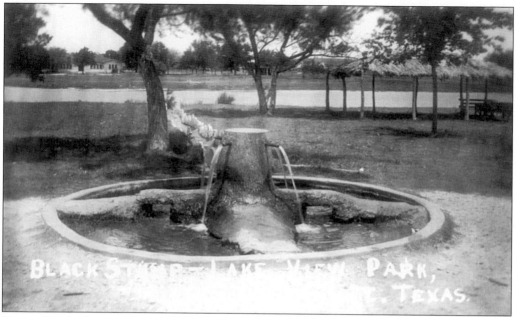

Pictured is the famous Stump Well. (See more on the Stump in Chapter 6.) (Don and Vivian Hill Collection)

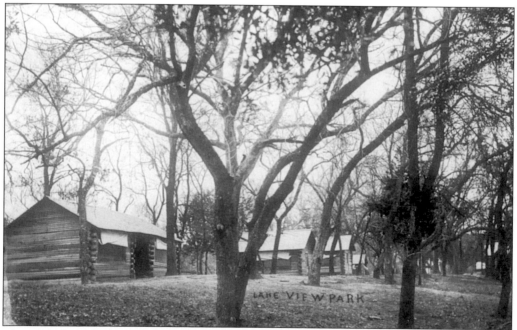

These are the Lake View cabins in the woods. (Don and Vivian Hill Collection)

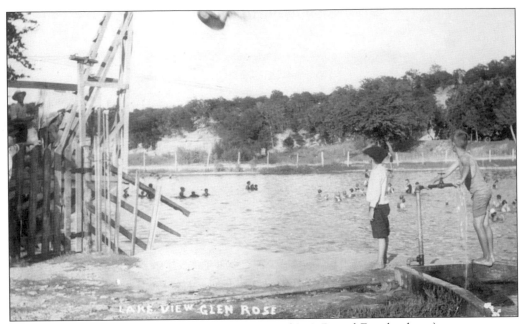

Geronimo! "What are you landlubbers lookin' at?" (G. I. Daniel Family photo)

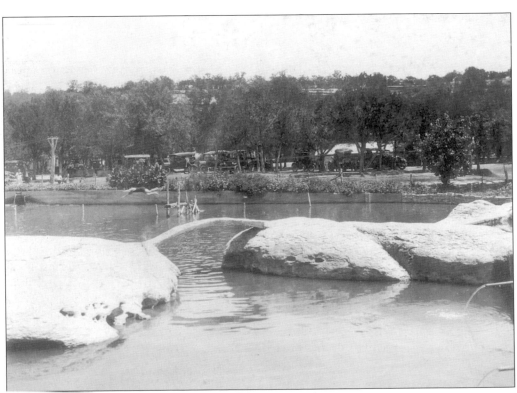

Bridge over untroubled water. (G. I. Daniel family photo)

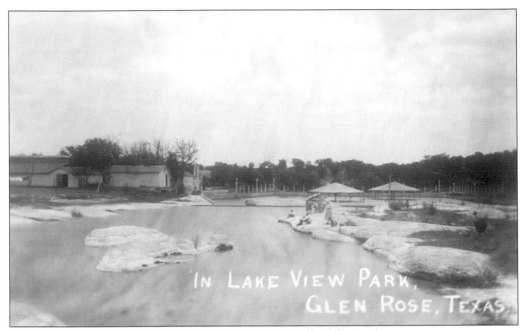

Here is another Lake View scene. (Don and Vivian Hill Collection)

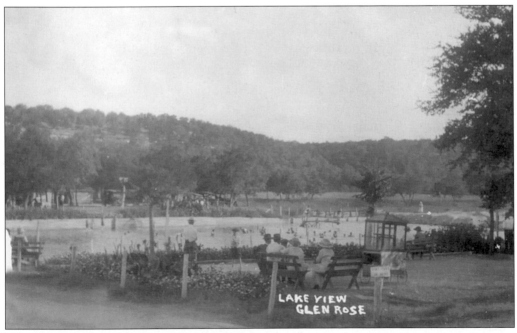

Viewing the lake. (G. I. Daniel Family photo)

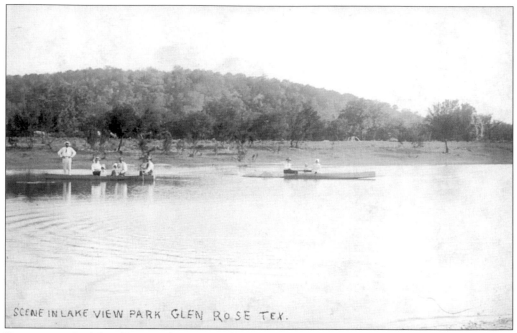

SCENE IN LAKE VIEW PARK GLEN ROSE TEX.

Boating on the lake. (Don and Vivian Hill Collection)

Opening day at Lake View celebrates the beginning of the tourist season on May 26, 1921. Pictured, left to right, are Laura Milam (Riddle), Nanny Lucille Knott, Allie Raifsnider, Ruth Martin, Gwendolyn Gibbs (McLemore), Astor Boone (Baty), Naomi Embree (Burmeister), and Maxie Parker (Leach) kneeling in front. (Courtesy of Maxie Leach)

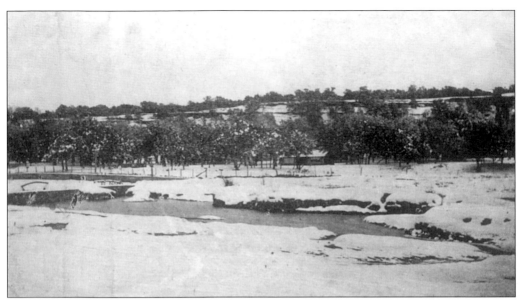

Pictured is Lovers Leap across the Paluxy from Lake View with snowfall. (Don and Vivian Hill Collection)

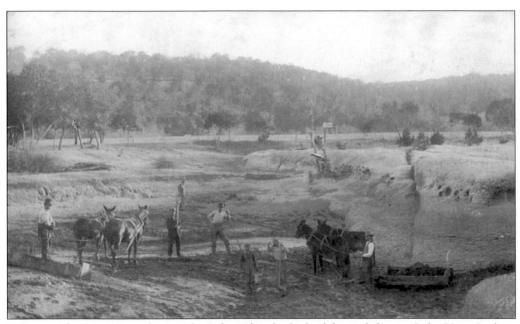

"This may be," says Dorothy Leach, "when they built the lake and dam at Lake View Park to keep out the Paluxy." (G. I. Daniel Family photo)

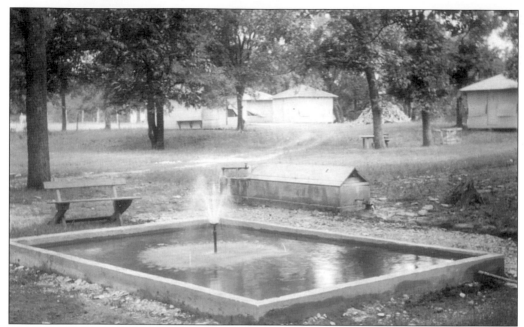

This is the flowing well at Wright's Park on Wheeler Branch. (Don and Vivian Hill Collection)

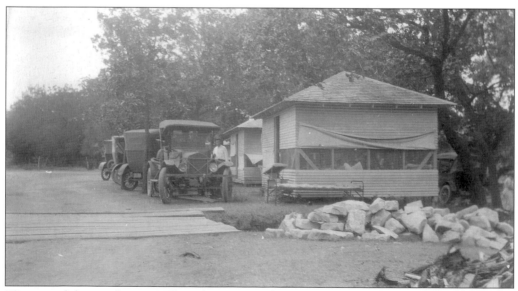

"Get out of the car, honey." The cabins at Wright's Park had flaps that could be raised for a breeze. (Don and Vivian Hill Collection)

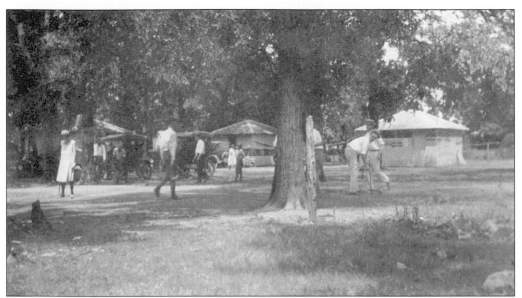

Croquet was one of the pleasant diversions at Wright's Park, north of present Highway 67. (Ruth F. Parker Collection; Booker Family photo)

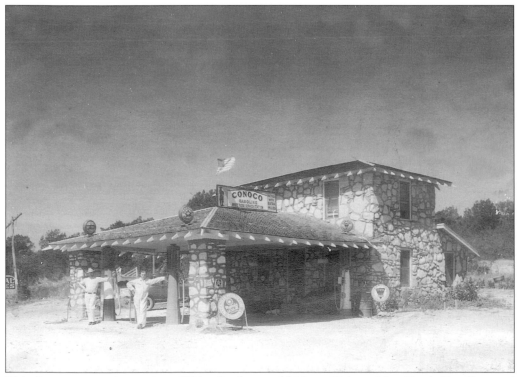

This limestone service station, White Rock, on old Hwy. 67 (now Van Zandt Road) served Glen Rose bootleg liquor during Prohibition. Over-imbibers could sleep it off in a nearby roadside park. (Copy courtesy of Frank Laramore)

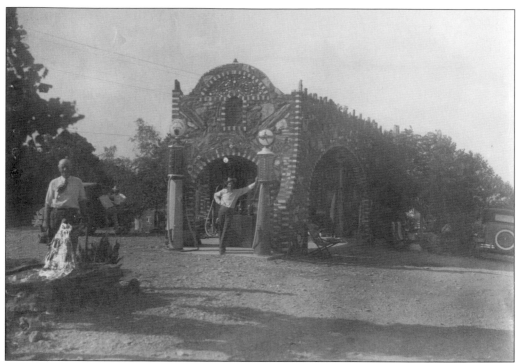

Ed Young's Service Station, a companion honky-tonk to White Rock nearby, made Forks of the Road very popular with cars lined up every which way. (Courtesy of Wynama Young Wilson)

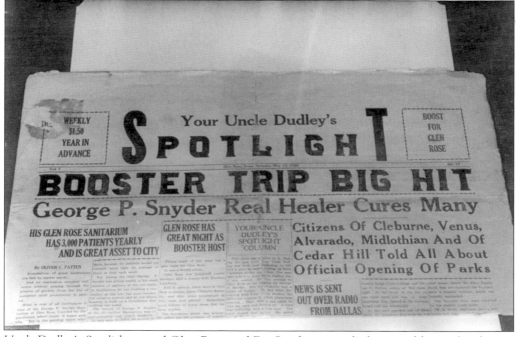

Uncle Dudley's Spotlight touted Glen Rose and Dr. Snyder to catch the eye of future developers. (Eugene Connally Collection, Somervell Co. Historical Commission; photo by Linda Drake Photography.)

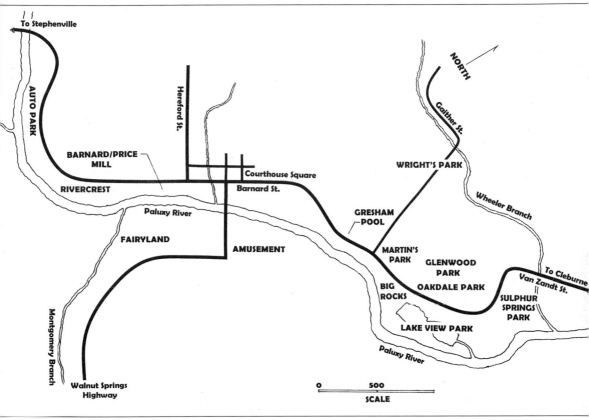

To Stephenville

AUTO PARK

Hereford St.

NORTH

Gaither St.

BARNARD/PRICE MILL

WRIGHT'S PARK

Courthouse Square

Wheeler Branch

RIVERCREST

Barnard St.

Paluxy River

GRESHAM POOL

FAIRYLAND

MARTIN'S PARK

AMUSEMENT

GLENWOOD PARK

To Cleburne

Van Zandt St.

BIG ROCKS

OAKDALE PARK

SULPHUR SPRINGS PARK

Montgomery Branch

LAKE VIEW PARK

Paluxy River

Walnut Springs Highway

0 500

SCALE

MAP (Courtesy of Ken Fry)

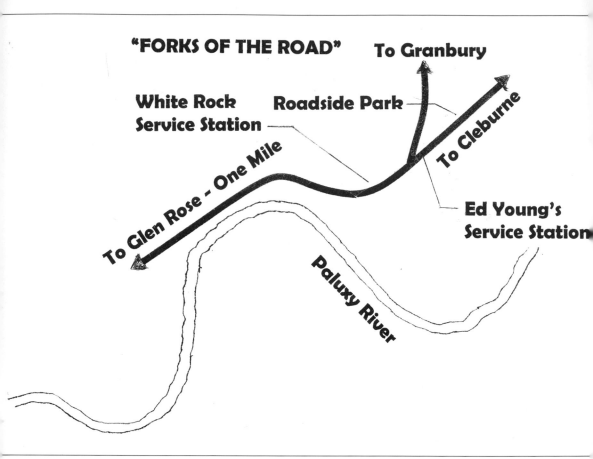

MAP—Forks of the Road (Courtesy of Ken Fry)

Six

FLOWING WELLS

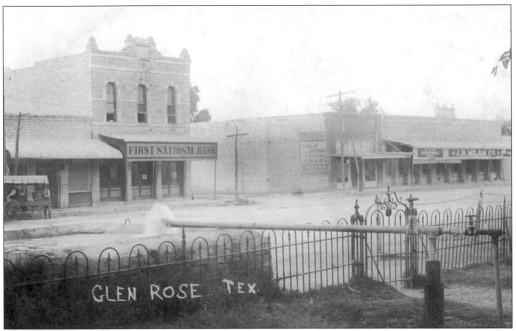

The flowing well at the courthouse was one of the first drilled in Glen Rose, in the early 1880s. Residents celebrated with an all-night dance and bonfire on the square when the flow commenced. For a time, the water flowed into a horse trough, which became a popular dunking spot for bridegrooms. (Don and Vivian Hill Collection)

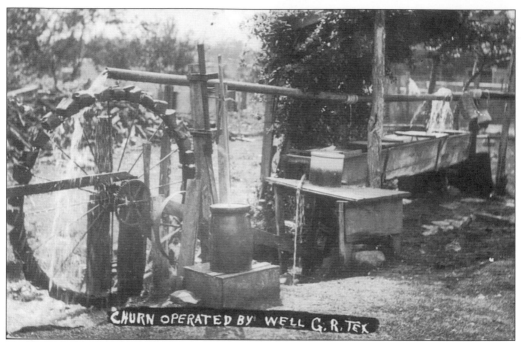

This is an ingenious application of the water from a flowing well: churning butter. (Somervell County Museum)

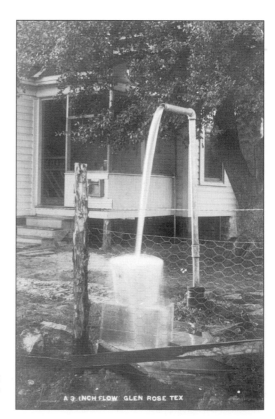

The Otey Well, a three-incher, was located at the corner of Hereford and Vernon. (Ruby Gresham Leach Collection)

The Morton Well may have been up Shotgun Road near Wheeler Branch. (Don and Vivian Hill Collection)

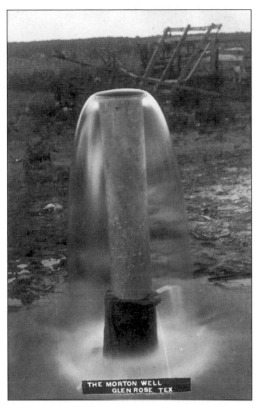

THE MORTON WELL
GLEN ROSE TEX

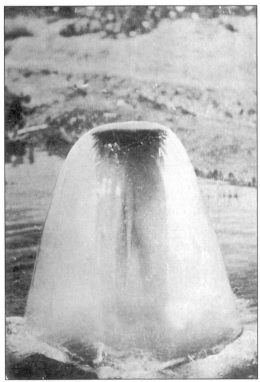

A six-inch flowing well is shown here on the Milam farm. By the 1920s, there were at least 200 flowing wells in Glen Rose. (Don and Vivian Hill Collection)

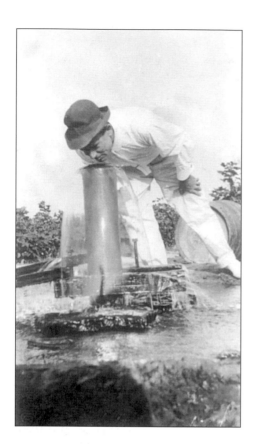

Hits the spot. (Ruth F. Parker Collection; Booker Family photo)

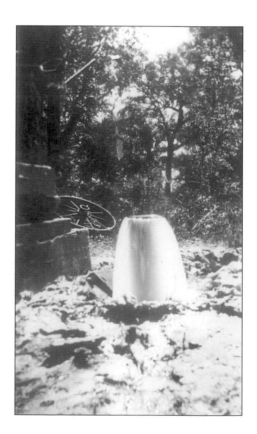

Pictured is the Y.W.C.A. Camp well (now Tres Rios), a private camp at that time and not generally available to locals or tourists. (Don and Vivian Hill Collection)

Lake View Park owner G.I. Daniel is photographed with a flowing well. (Courtesy of Dorothy Leach)

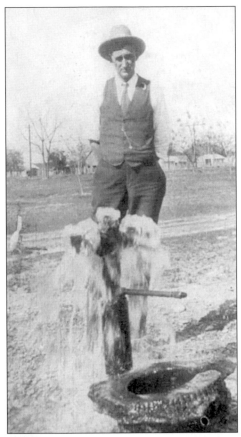

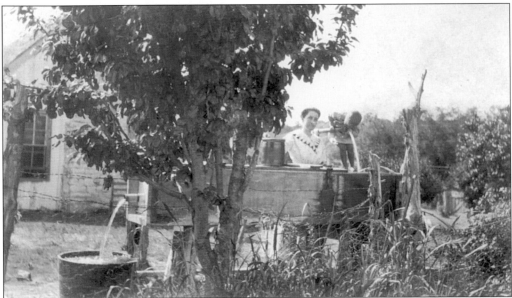

Like the old-time "spring houses," this residential water system used the water from a flowing well to cool milk, butter, and other perishables in the long container. (Courtesy G. I. Daniel Family photo)

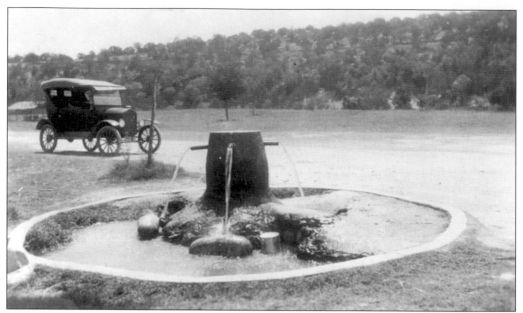

Pictured here is the famous Stump Well at Lake View Park. Robert E. McDonald told the late Glen Rose historian Ruth Parker that he and George Daniel poured an old barrel full of concrete to form the faux tree stump. They connected the well's double casing to two separate strata of 110 feet and 300 feet, producing waters of different mineral content. Tourists were told that each of the well's four spouts delivered a different brand of mineral brew. An elderly Cisco chiropractor reported in 1990 that, as a boy, the Stump water healed a gash on his head in record time. (Don and Vivian Hill Collection)

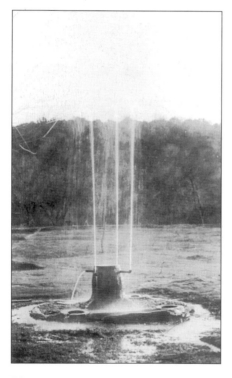

When three of its founts are pointed up, the Stump puts on a show. (Virginia Smith Collection; Somervell Co. Historical Commission archives)

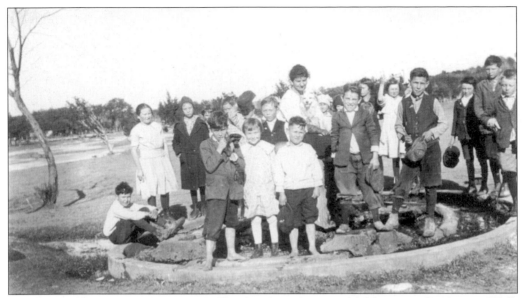

Josephene "Phenie" Booker (Campbell) takes her class on a field trip to the Stump Well. (Booker Family photo)

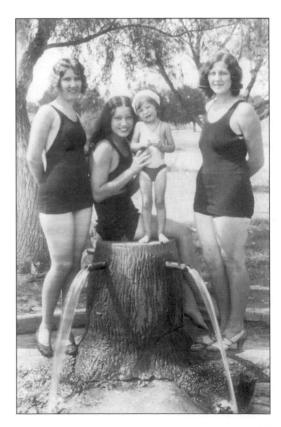

Ethel Luten (Connally), Oleta Daniel holding Jo Ella Daniel, and Margaret Danner Daniel at the famous Stump Well. (Courtesy of Jerry Dan Osborn)

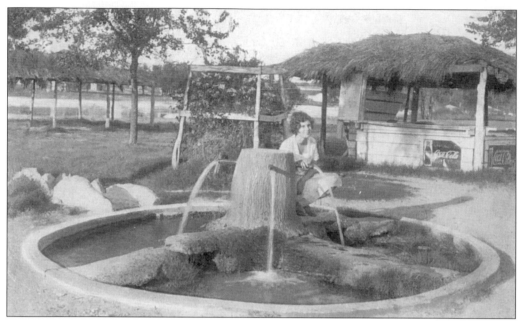

A concession stand with a roof made of the reeds from the lake was the peak of attraction at the Stump Well. (Don and Vivian Hill Collection)

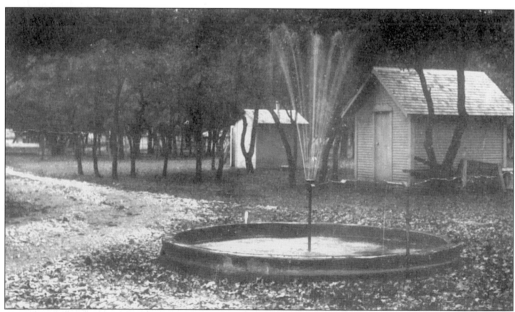

Goldfish frolicked in this fountain of dancing waters at Glenwood (or McAllister) Park. (Don and Vivian Hill Collection)

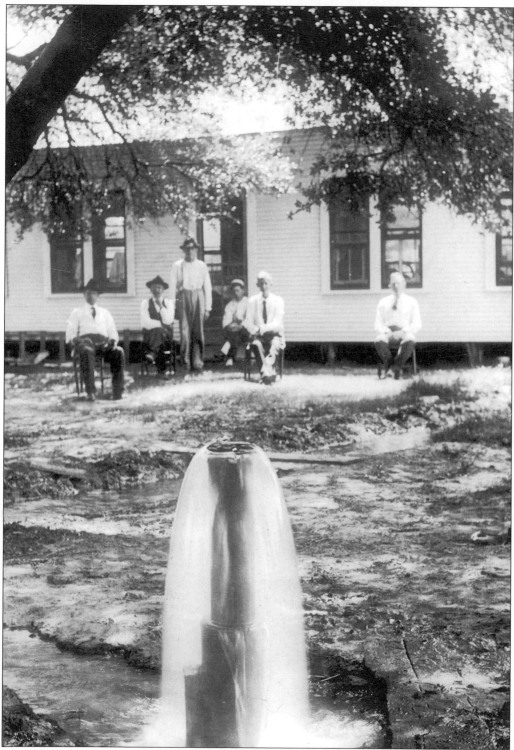

Sanitarium patients soothe their frazzled senses by watching the water cascade to the ground. (Virginia Smith Collection; Somervell Co. Historical Commission archives)

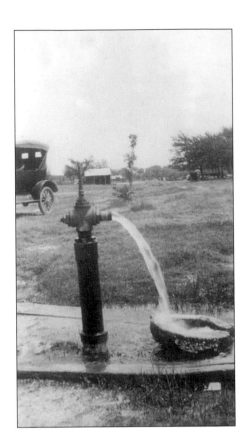

The flow from this well in Lake View Park was a four-incher. (Don and Vivian Hill Collection)

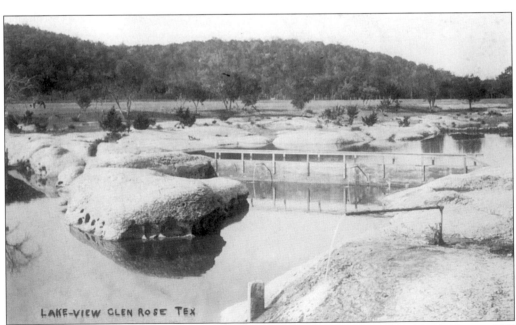

LAKE-VIEW GLEN ROSE TEX

Shown here is a flowing well into the lake at Lake View Park. (Don and Vivian Hill Collection)

Seven

"Where People Get Well"—Santariums and Healers

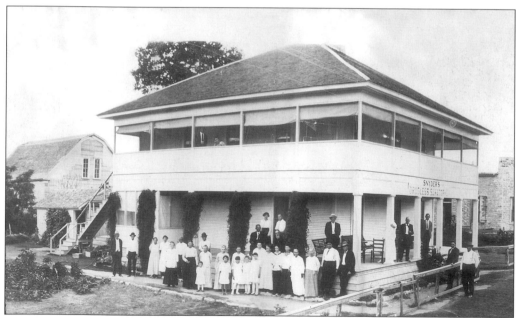

The first sanitarium, on Elm Street near the bridge, of another magnetic healer, Dr. George Snyder. Many of the Glen Rose healers stressed the "drugless" nature of their treatments. (Somervell County Museum)

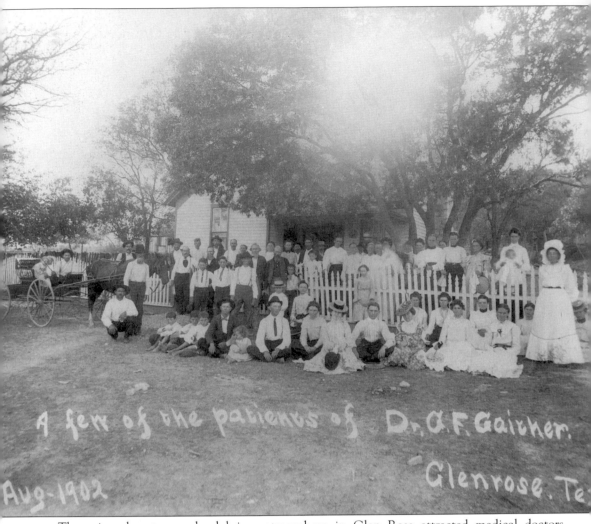

A few of the patients of Dr. G. F. Gaither. Glenrose, Te[x]

Aug-1902

The mineral waters and salubrious atmosphere in Glen Rose attracted medical doctors, chiropractors, massage therapists, and maverick folk healers. Along with the town's parks, sanitariums have accounted for a hefty portion of the local economy. Dr. G. F. Gaither, an osteopath, opened one of the first sanitariums around the turn of the century. The Gaither Sanitarium, transformed to a bed and breakfast, still stands near the square in 2001. (Somervell County Museum)

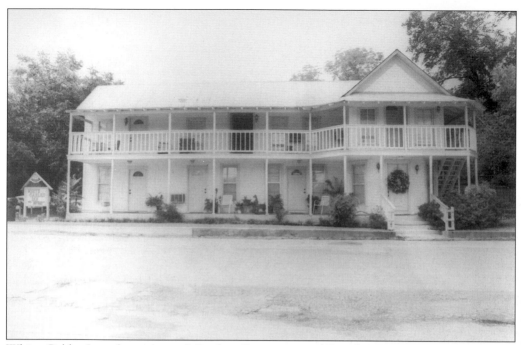

White Gables Inn, the renovated Gaither Sanitarium and Boarding House, is now a bed and breakfast. (Somervell Co. Historical Commission; photo from Linda Drake Photography)

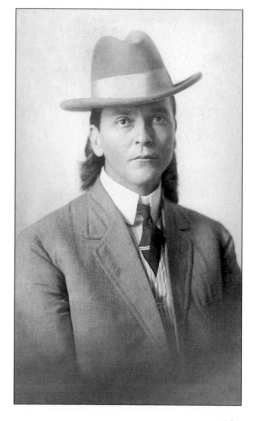

Dr. R.G. Milling Sr., a part Cherokee magnetic healer known as the Indian Adept and the Long-Haired Doctor, added therapeutic suggestion to his massage and faith-healing treatments after witnessing a "Hindu hypnotist" demonstrate his art in Glen Rose in the 1890s. Though R.G. Sr. practiced elsewhere, younger brother G.R. Milling, shown here, set up shop in Glen Rose in 1911. The sheriff was a frequent visitor to G.R.'s sanitarium, but not for treatment. Charges lodged against the independent-spirited healer ranged from driving his Hupmobile down Barnard Street in excess of the 18 mph speed limit to disturbing a religious congregation. G.R. was also nabbed for toting a pistol in town and once for "unlawfully shooting a gun across a public road." A few cases involved his going on a bender, and another alleged the doctor had threatened to take a life. In September 1914, he was killed near the courthouse by blasts from a double-barreled shotgun, possibly by the irate husband of a female patient. The fact that magnetic healers were sometimes called "rubbin' doctors" might explain the act of tragic passion. (Most of the healers, it should be noted, were more sociable and were readily embraced by the community.) (Somervell County Museum)

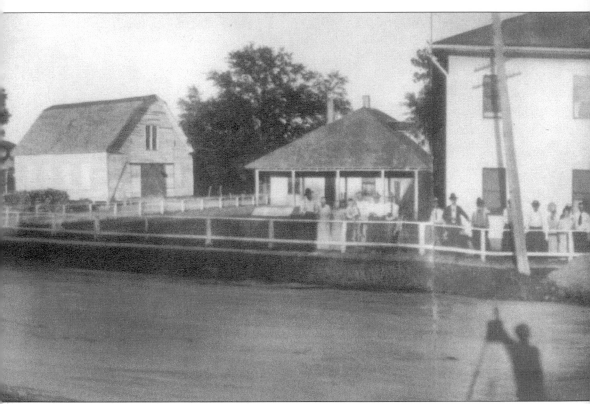

This is a panorama view of George Snyder's main sanitarium building, built in 1919 on Barnard.
In 2001, this building houses the elegant Inn on the River. Note photographer's shadow on the

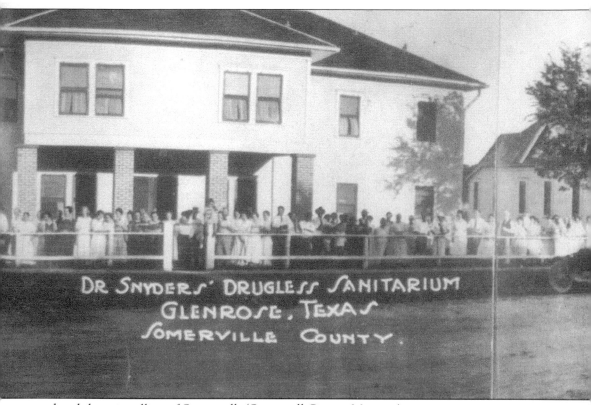

road and the misspelling of Somervell. (Somervell County Museum)

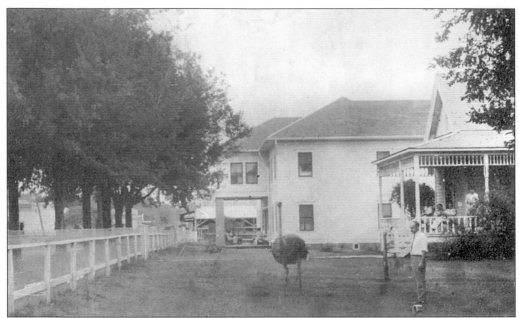

Dr. Snyder stands near his pet ostrich, Judy. His biographer, Elna Martin, described Snyder as a "little wizard" and "a real human X-ray" with clairvoyant powers. "The special advantage he has over the regular M.D. or even specialists is his ability to read the patient's mind." (Don and Vivian Hill Collection)

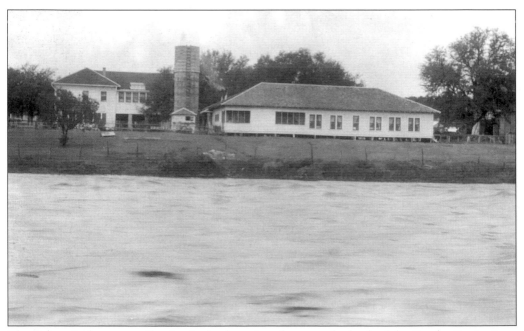

The Paluxy is shown overflowing its banks as it rushes past the back of the Snyder Sanitarium. Once, the doctor kicked all the patients out of his clinic after learning they had been slipping across the river to see a fortune teller, explaining that he could not heal under such "mental cross currents." (Don and Vivian Hill Collection)

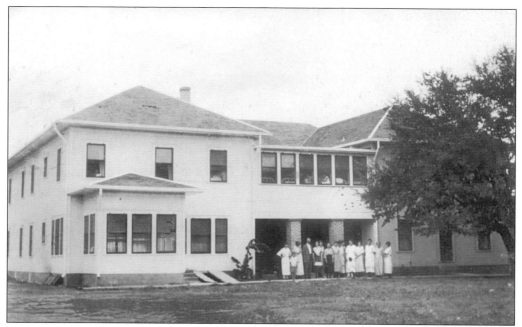

Pictured is the rear view of Snyder's. Jeanne Mack of the Somervell County Museum recalled that Snyder's patients sat in chairs for the magnetic treatment while the wizard or one of his staff healers rubbed away illness with firm motions that caused a finger snap at the end of each stroke. (Don and Vivian Hill Collection)

The Snyder Sanitarium Annex took care of the overflow of patients next door. News reports chronicled the magnetic healer's wondrous ability to restore sight. Even legendary Texas rancher Charles Goodnight visited the sanitarium in the 1920s seeking help for his eyes. One old farmer, seeing ostrich Judy cavort about, shouted, "That bird is as big as a cow! Those...fellows have ruined my eyes!" In addition to Judy, the grounds also housed a peacock, a baby alligator, wolves, and other animals. (Don and Vivian Hill Collection)

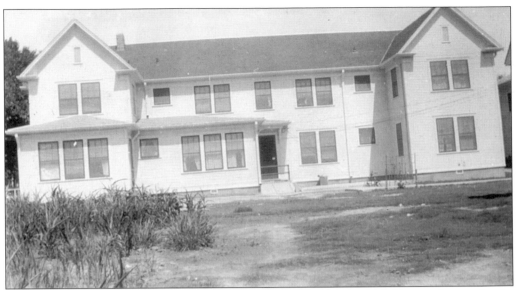

This is a rear view of the Annex (burned in the 1980s). Another noted Texan who sought the Snyder treatment, controversial preacher J. Frank Norris stayed at Snyder's while in Glen Rose for a tent revival. "In 10 minutes conference," reported the minister known as the Texas Tornado, "he gave me information worth $10,000. He took my appendix out of my head. I thought I had a bad appendix although operated on for appendicitis some years ago. Snyder told me there was only a stub left. Consequently my appendicitis was only in my head and he took it out." (Don and Vivian Hill Collection)

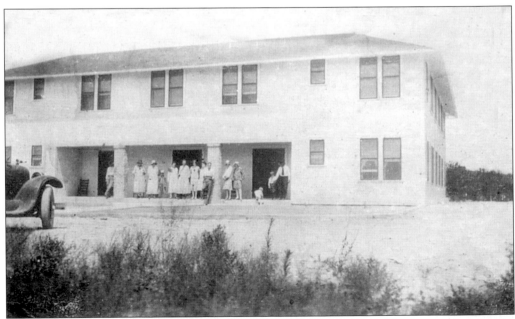

Dr. Gus Snyder, George's brother, had a sanitarium at the end of Cedar Street, overlooking the town. (Don and Vivian Hill Collection)

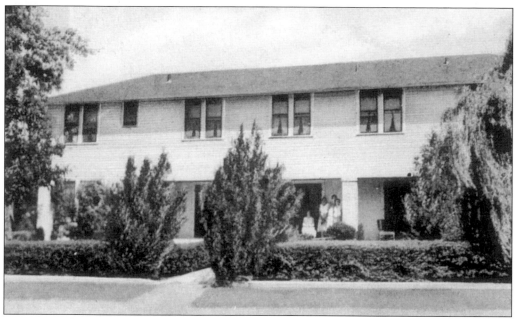

Here is another view of Gus' magnetic healing clinic. (Don and Vivian Hill Collection)

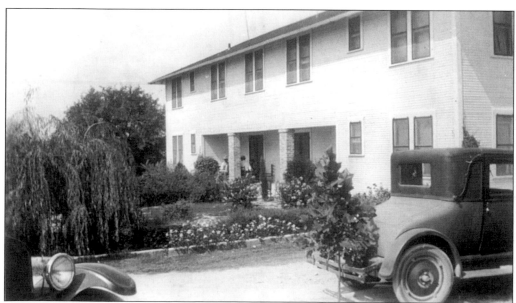

View of Dr. Gus' sanitarium. (Don and Vivian Hill Collection)

The unidentified sanitarium pictured here was located on the corner of Barnard and Pecan. The sign reads "Magnetic Healer". It later became a hotel. (Ruth F. Parker Collection; Booker photo)

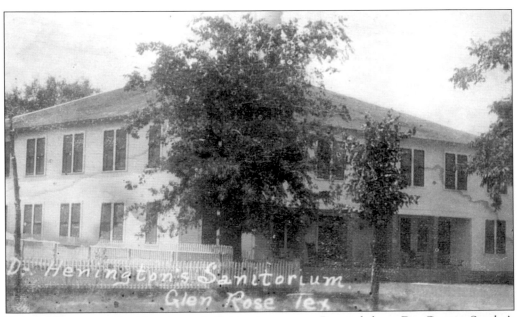

This building was Dr. Hennington's Sanitarium across Barnard from Dr. George Snyder's Sanitarium. (Don and Vivian Hill Collection)

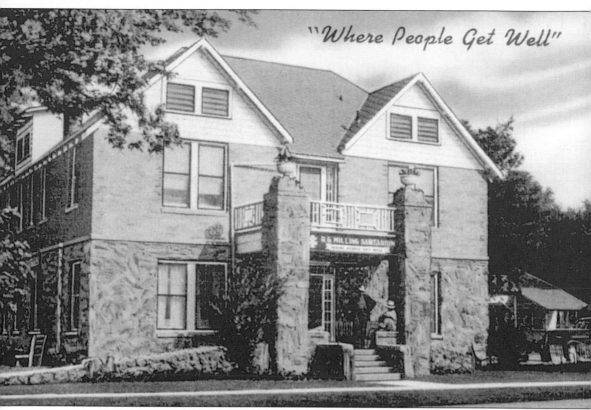

"Where People Get Well"

"Where People Get Well," read the sign at the R.G. Milling Sanitarium, operated in the family tradition by R.G. Milling Jr. from the late '40s to the early '60s. One correspondent wrote to the folks back home in Muenster on a Milling postcard in 1952 that "there sure is a nice bunch of people here - not so high-falutin'." (Courtesy of Gene Fowler)

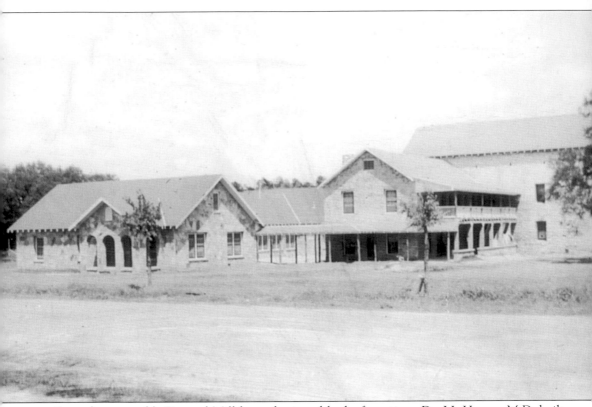

Even the venerable Barnard Mill housed mineral baths for a time. Dr. J.J. Hanna, M.D. built the one-story for a clinic/hospital and gave healing baths in the mill building. The one-story building is presently Barnard's Mill Art Museum (Ruby Gresham Leach Collection)

Eight

PETRIFIED WOOD

An abundance of wood that time and chemical process had turned into stone in the area gave Glen Rose another nickname, the "Petrified City." Starting in the mid-1920s, it became popular to outfit homes and buildings in the village with a veneer of the aesthetically-pleasing petrified wood. Farmers were glad to find a market for it; lying just below the surface, the rock wood could wreak havoc on a plow. (Somervell Co. Historical Commission; photo by Linda Drake Photography)

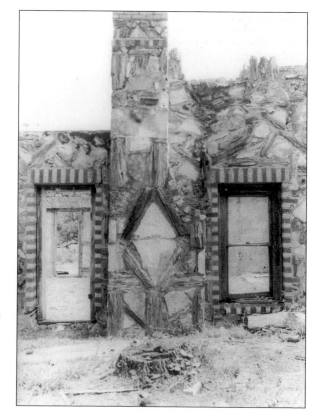

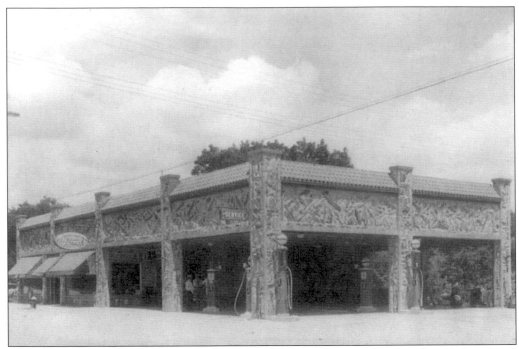

Lane's Ford Agency and Garage, shown here, still stands in 2001 on Barnard near the square. Gran Norman was the rock mason/artist for this building and many others of this type. (Courtesy of Lynn Lane)

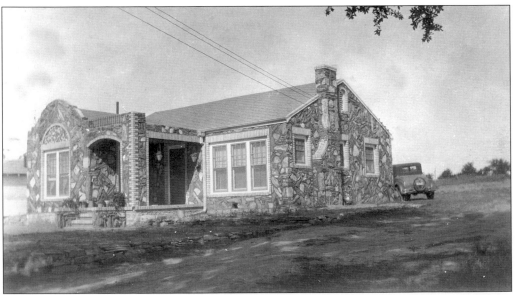

Truck driver Wesley Marsh borrowed $1,400 from magnetic healer George Snyder to build this "honeymoon" cottage as a surprise for his bride, Marvin Morton. (Ruth F. Parker Collection; Booker Family photo)

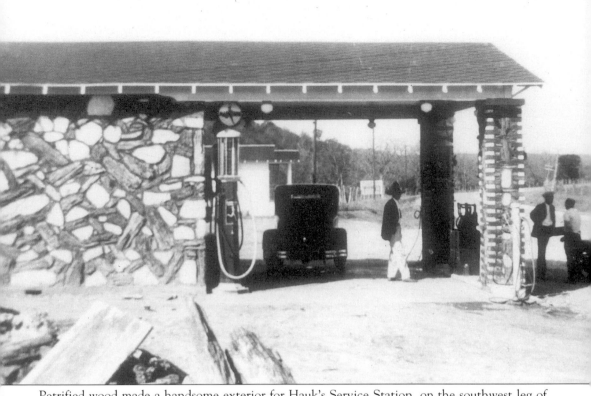

Petrified wood made a handsome exterior for Hauk's Service Station, on the southwest leg of Barnard. It still stands in 2001. (Somervell Co. Historical Commission; Novella Wilson photo)

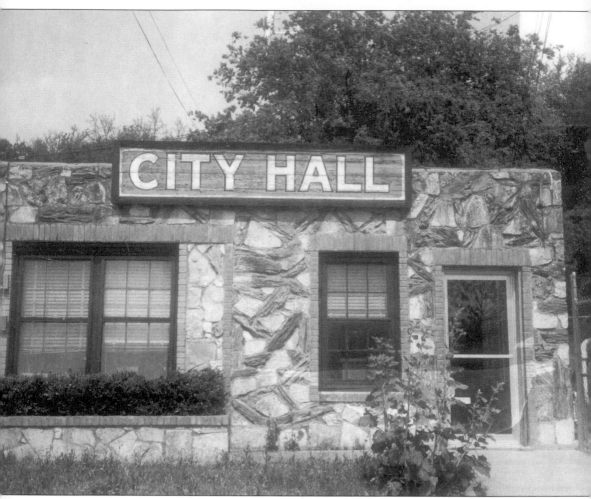

Even City Hall, shown here, got the treatment. Where the double windows are was once the doorway for the second-hand LaFrane firetruck. (Somervell Co. Historical Society)

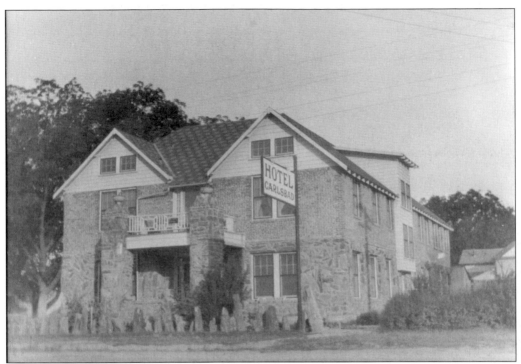

The (R.G. Jr.) Milling Sanitarium on Barnard was Hotel Carlsbad at some point. Later, renamed Shady Inn, it served for a time as an antique mall. (Courtesy of Johnny and Marvilene Martin)

Tom Campbell built this fast food cafe from petrified wood on the corner of Barnard and Pecan, next to his father's Campbell Building. Carhops served Tom's famous hamburgers to customers. The sign in the window says "Petrified Wood for Sale." (Courtesy of Paul Bone)

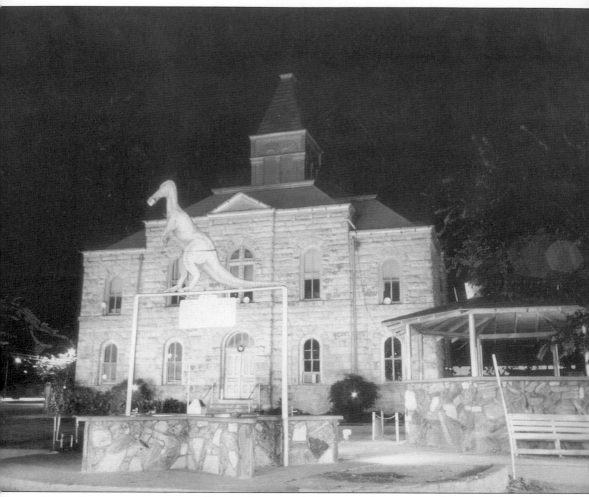

For a time, a six-foot, metal Trachodon named Tex rose above a star-shaped well made of petrified wood on the courthouse lawn. A sign detailed the water's mineral content. Park-bench philosophers held court at the well, often enjoying a refreshing chug. "To the local citizens," says Dorothy Leach, "the sulphurous taste was water to please the gods on a hot July day, but to the visitor it was worse than a dose of medicine with its rotten-egg odor." The bandstand on the right is also made with petrified wood. (Somervell County Museum)

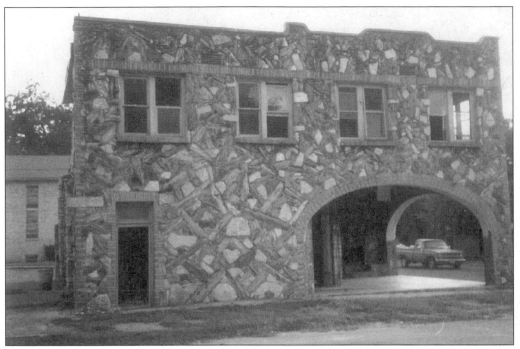

Built in the early 1900s by W.D. "Doc" Nowlin (a local entrepreneur and pretty good horse doctor), Nowlin's Service Station got a petrified wood makeover around 1925. It was torn down sometime after 1990. (Courtesy of Johnny and Marvilene Martin)

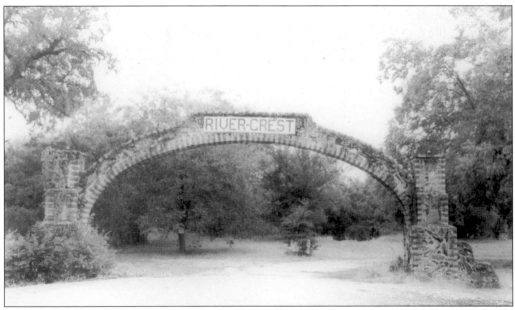

The petrified wood arch at River Crest Park still graces Barnard in 2001. (Somervell Co. Historical Commission; photo by Linda Drake Photography)

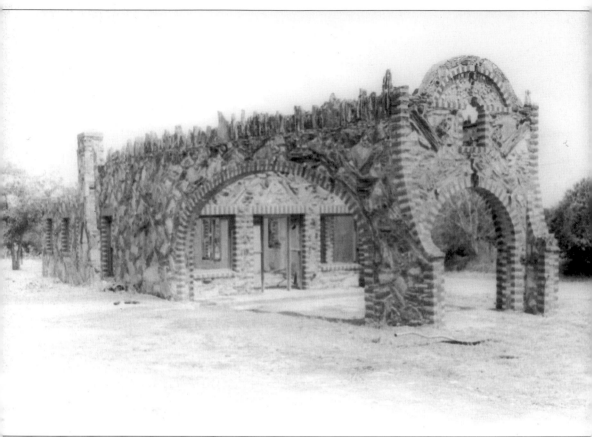

Sycamore Grove a.k.a. Ed Young's, a petrified-wood gas station/roadhouse, served bootleg booze during Prohibition. Along with the honky-tonk White Rock (see parks), Sycamore Grove made up a wild-side-of-life zone called "Forks of the Road" on old Hwy. 67, on the eastern outskirts of town, now Van Zandt Road. In 2001, Sycamore Grove awaits a planned restoration. (Somervell Co. Historical Commission; photo by Linda Drake Photography)

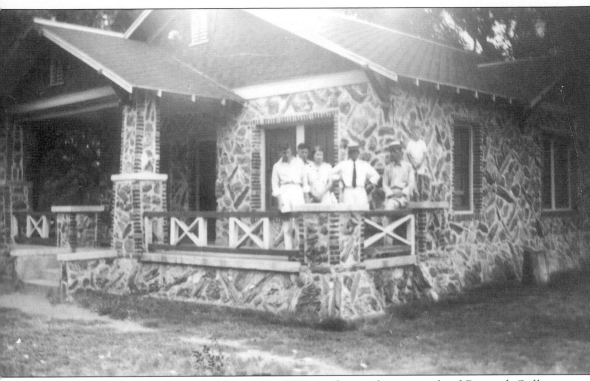

Lewis Gresham built this petrified beauty in 1929 on the northeast stretch of Barnard. Still standing in 2001, it backs up to the Paluxy. (Ruby Gresham Leach Collection)

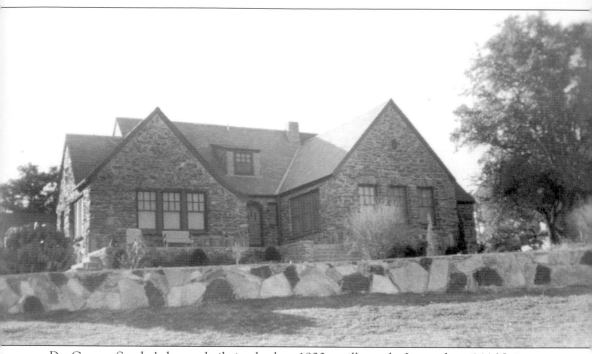

Dr. George Snyder's home, built in the late 1920s, still stands. Located on 144 N, it was a country retreat for the busy healer. (Glen Rose Garden Club scrapbook; Somervell County Museum)

Nine

COURTHOUSE AND JAILHOUSE

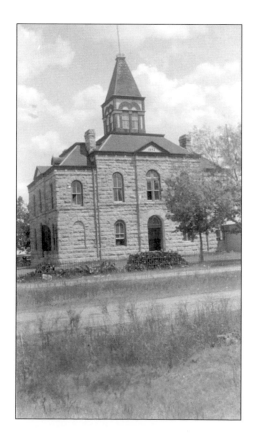

Pictured is the Somervell County Courthouse, c. 1920s. (Don and Vivian Hill Collection)

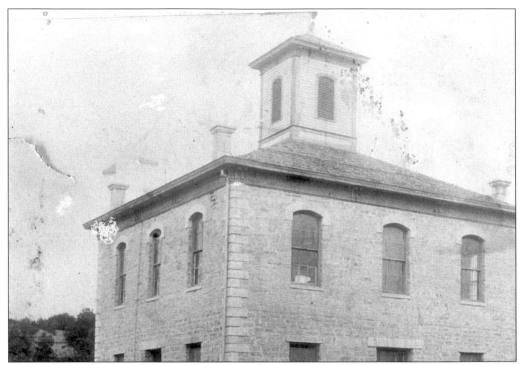

This is the first Somervell County Courthouse that was built on the square. Work progressed to the top of the first floor windows and stopped; it was finished some time in the late 1880s. (Courtesy of Brother E. B. McCown; Somervell Co. Historical Commission)

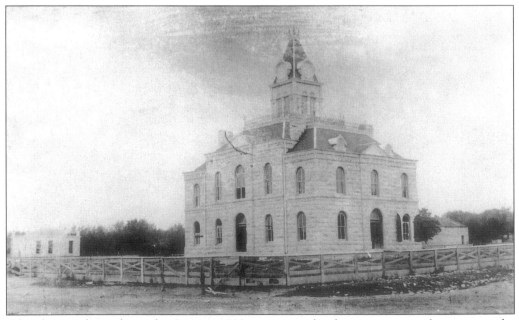

After the courthouse burned in January 1893, a new temple of justice arose on the square in the same year. Note the jail at the left. (Courtesy of Brenda Buzan Ransom; Lloyd Don Moss records)

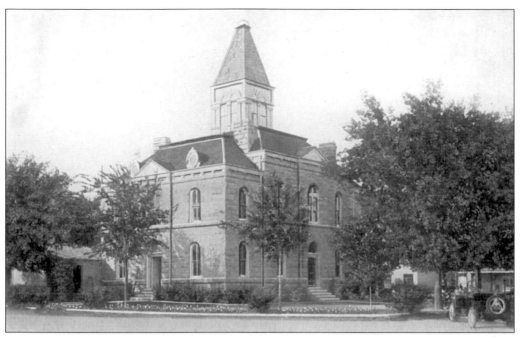

By the 1930s, a handsome landscape surrounded the castle of county archives. (Don and Vivian Hill Collection)

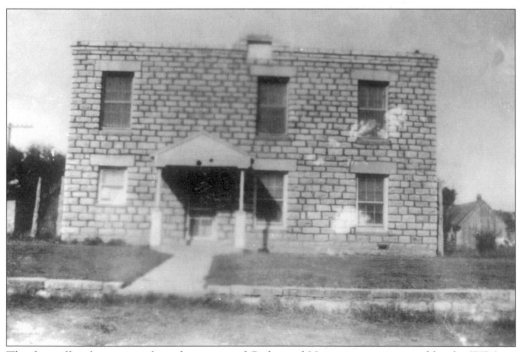

The first official county jail on the corner of Cedar and Vernon was renovated by the WPA in the 1930s. (Somervell Co. Historical Commission; Kenneth Trimble photo)

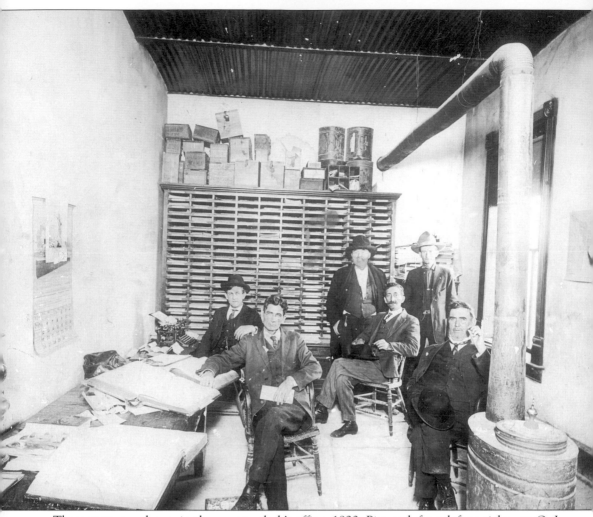

These gents are shown in the county clerk's office, 1922. Pictured, from left to right, are O. J. Covey, Willis Holder, George Shackelford, F. B. Kirby, Sheriff Walter Davis, and Judge S.G. Tankersley. (Somervell County Museum)

Ten

TEXAS TORNADO

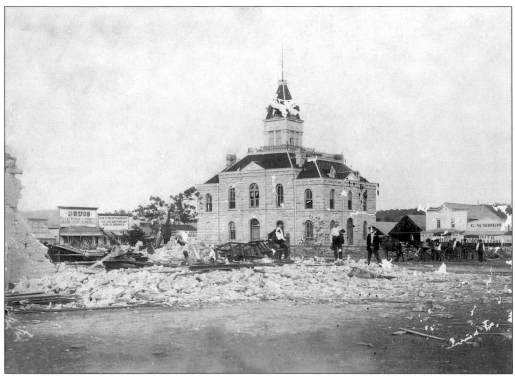

On April 28, 1902, a terrible cyclone (colloquial term for tornado) roared through Glen Rose, killing six people and shredding dozens of homes and buildings. The courthouse sustained only minor damage. (Somervell County Museum)

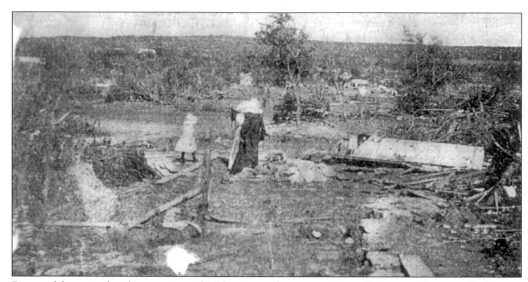

Pictured here is the devastation of Milam's residence on Barnard Street. (Somervell County Museum)

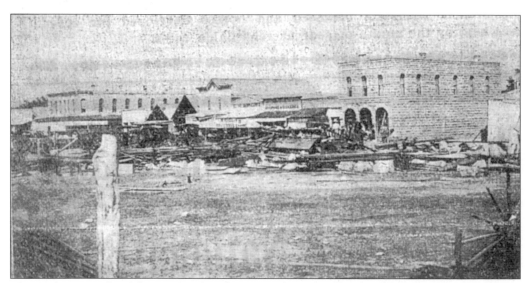

This is the east side of the square after the storm. (Somervell County Museum)

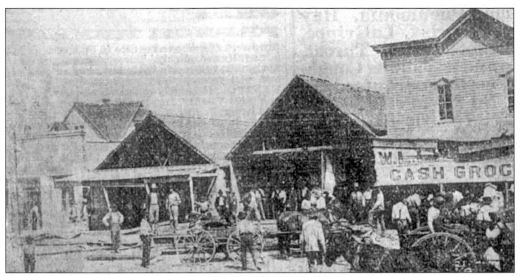

This is Martin's Saloon and W.L. Lilly's store. (Somervell County Museum)

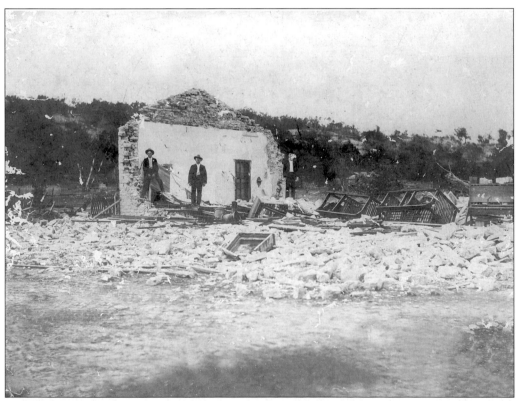

A lone wall was left standing at the offices of the *Glen Rose Herald*. The stone building was rebuilt and now houses the Somervell County Museum. (Somervell County Museum)

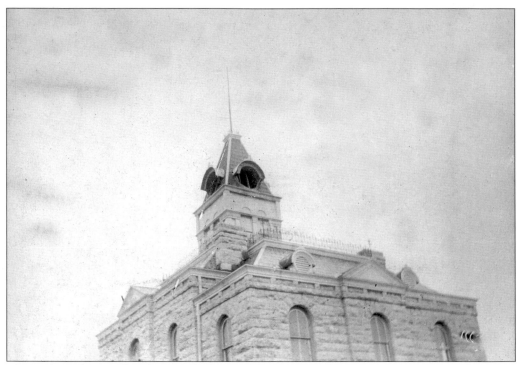

The roof was damaged and tower clocks were blown out on the courthouse. (Somervell County Museum)

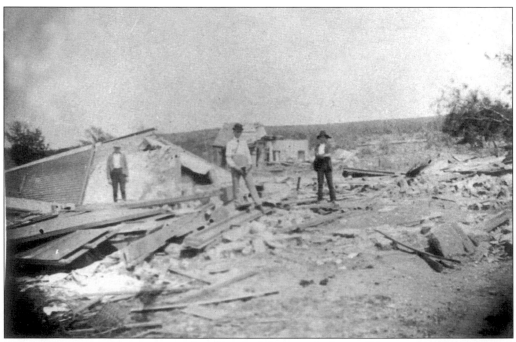

Some of the worst damage occurred on Hereford Street, which is still known locally as Cyclone Street 100 years later. Only one house on this street was left standing. (Somervell County Historical Society)